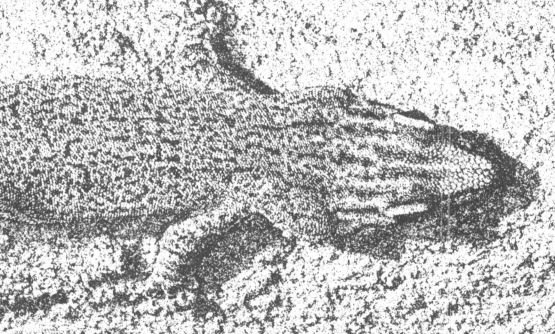

CAMOUFLAGED WILDLIFE

First published in 2017 by Reed New Holland Publishers Pty Ltd
London • Sydney • Auckland

The Chandlery, Unit 704, 50 Westminster Bridge Road, London SE1 7QY, UK
1/66 Gibbes Street, Chatswood, NSW 2067, Australia
5/39 Woodside Avenue, Northcote, Auckland 0627, New Zealand
www.newhollandpublishers.com

A record of this book is held at the British Library and the National Library of Australia.

ISBN 978 1 92151 786 0

Group Managing Director: Fiona Schultz
Publisher and Project Editor: Simon Papps
Designer: Andrew Davies
Production Director: James Mills-Hicks
Printer: Times International Printers, Malaysia

10 9 8 7 6 5 4 3 2 1

Keep up with New Holland Publishers on Facebook
www.facebook.com/NewHollandPublishers

CAMOUFLAGED WILDLIFE

HOW CREATURES HIDE IN ORDER TO SURVIVE

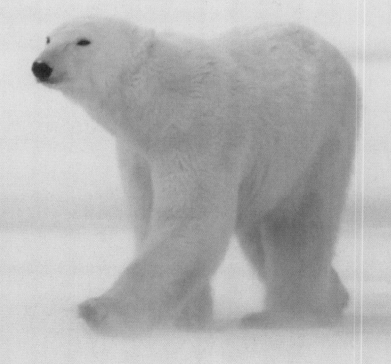

Text by Joe McDonald

Photos by Joe and Mary Ann McDonald

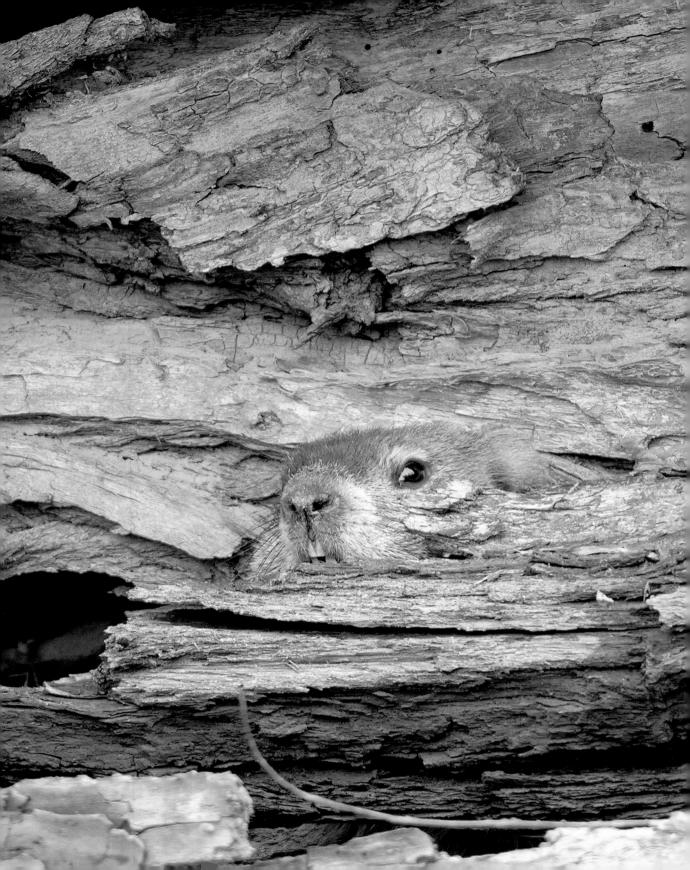

Contents

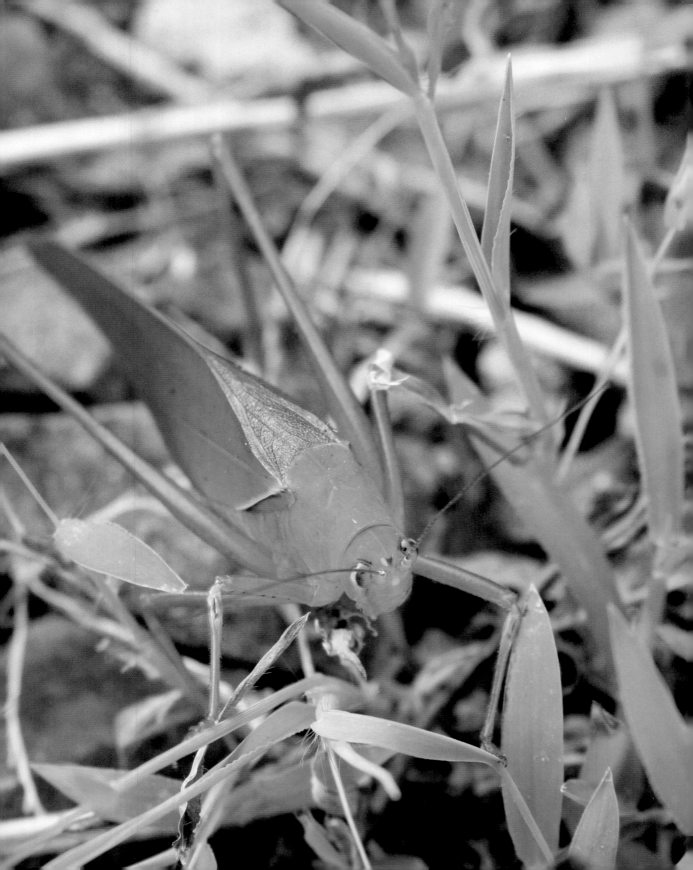

Introduction

Jungles, so the popular notion suggests, are filled with life, teeming with plants and animals, birds and insects, dangerous snakes and creepy spiders. And yet, as I walked quietly down a dimly lit trail in the jungles of southern Panama, surrounded by towering trees and sheltered by a rooftop of thick foliage from the punishing sunlight of high noon, I was seeing nothing. Then I stopped, perhaps to decide which of two trails I should take, and as I stood there, not really looking at anything in particular, I began to see. In the overall stillness, the darkness that branched off in all directions, the shafts of light piercing through the canopy in hazy columns, and the visual chaos of bright leaves and deep shadows, this seemingly barren landscape slowly came alive before my eyes.

I didn't see a jaguar or a monkey or a parrot as my eyes and mind opened up to what was hidden right there before me. Instead, the first thing I saw was a motionless katydid, but until I actually focused my attention on this insect all I saw was another weathered leaf lying on a vine less than half a metre in front of me. The katydid was a leaf-mimic, shaped so well that it was a dead ringer for a real leaf, except for its six legs that I finally noticed. The wings of the katydid were veined just like a leaf, and these wings were held somewhat upright, as a leaf might be that had died and fallen and settled in the nook or crack of a vine or mossy limb. After discovering this insect, I suspected there was more, and that my eyes had missed other hidden creatures. With that in mind I slowly made a 360˚ turn, my eyes travelling up and down tree trunks and vines, across limbs, and sweeping across the forest floor. I did this slowly, attempting to take in details I had glossed over only moments earlier.

I can't say that the jungle suddenly exploded with living creatures, but as I completed my slow circle I quickly realized that there was life right there before me, hiding in plain view. There was a motmot, a large, jay-like bird, sitting motionless on the U of a hanging vine about 10 metres away, and right beside me, I noticed a large spider, its long legs fanned out and flattened so tightly against the smooth bark of a tree that it seemed to be a part of it. I soon spotted another katydid-like insect on another mossy branch, and not far from my booted feet I picked out a small toad that sat still and silent, looking like another piece of leaf litter if it were not for its small golden eyes.

I'll never forget that day in the jungle, now some 40 years ago. That one experience taught me to slow down, to look and to absorb, and to realize that much of what we can see in nature is not readily apparent. That certainly holds true for wildlife, be that an insect or a bird, a reptile or a mammal, for blending in, for not being seen, can be a matter of life or death.

Everyone has heard the phrase 'eat or be eaten,' and although this rather simplifies the way that nature

Opposite: A katydid's bright green leaf-like body and stem-like legs
help the insect to blend in perfectly with its surroundings.

works, the katydids, the toad, the motmot and the spider I saw on my slow turn on that jungle trail certainly illustrate the truth to that little generalization. The katydid eats leaves, but the wrong movement on the insect's part, a stretched leg or a waving antenna, might attract the spider. In turn, either the katydid, the spider, or the toad might be noticed by the motmot as it perches motionless on a high branch, scanning the ground and vegetation for unwary prey. The motmot's stillness is essential for this ambush predator, but its colour and stealth also protect it from predators of its own, the forest hawks and falcons, jungle cats, and boa constrictors that also lay in wait.

By their colour, their pattern, or their shape, these jungle animals all blend in with their surroundings and survive. The visual revelation I had in the jungle could have taken place almost anywhere in nature, be that in the treeless expanse of Alaska's arctic tundra or the saltgrass flatlands of New Jersey's coastal marshes. I could have had this epiphany snorkeling above a coral reef off Indonesia's coast, or sitting beneath an acacia tree in Kenya's Maasai Mara. In any of these locales, or virtually any other, there is a hidden world of wildlife, one not readily apparent to the more casual eye.

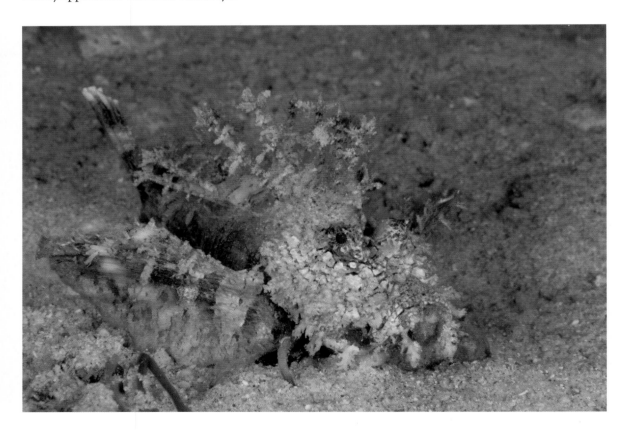

Above: A scorpionfish is difficult to distinguish from its seabed habitat. It relies primarily on camouflage for safety, but if that fails it has a row of highly poisonous dorsal spines.

Opposite: There are hidden treasures everywhere, if one watches carefully and does so with patience. These pygmy seahorses hiding in a coral reef in Indonesia are only a few centimetres long and remain motionless when approached, relying on their colour to remain unseen.

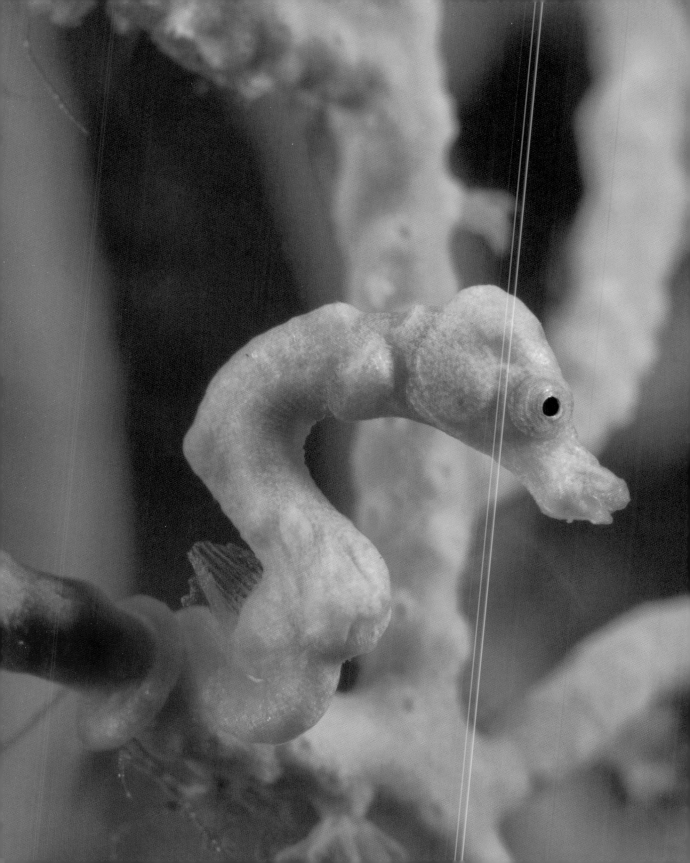

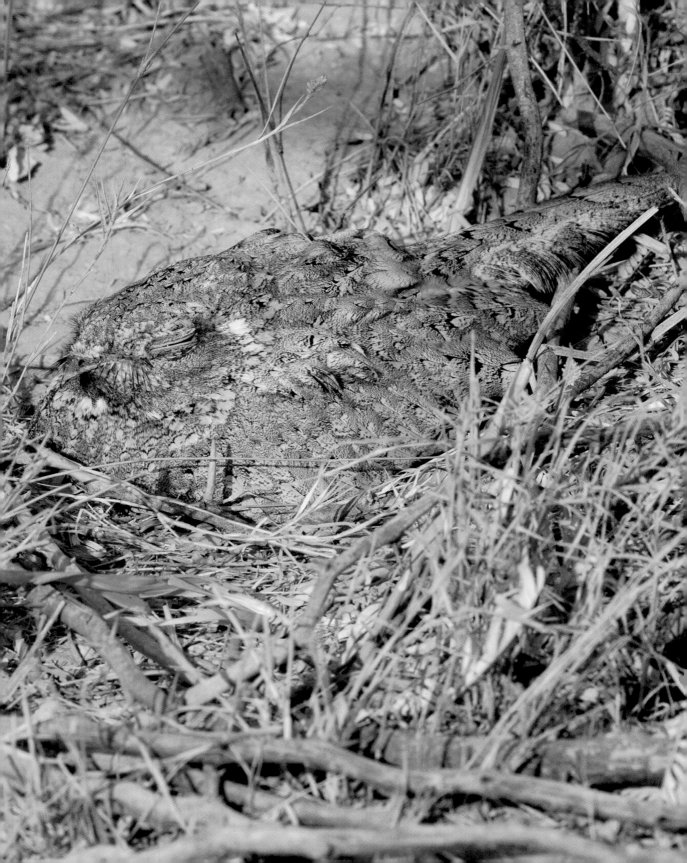

This book explores this hidden world of wildlife, the often unseen creatures that may simply be hiding in plain sight. In some, colour alone provides the camouflage, allowing a bird or an insect to simply blend in against its background. In others camouflage involves distinctive patterns – think of a tiger's stripes or a leopard's spots, to break up an animal's outline – again allowing the animal to virtually disappear within its surroundings. Some cryptic creatures have unusual shapes that mimic the features of their environment, a trick most commonly employed by fish and invertebrates and less frequently by some reptiles and amphibians. Marine and aquatic species go even further, adorning themselves with bits of vegetation or animal life to enhance this camouflage. Many do so with such fidelity that when they finally move it comes as a complete surprise, to either the human observer or to the prey item about to be consumed.

For every one of these animals, colour, pattern, shape, or combinations of these and several more are essential to their survival. There is a reason for these unique adaptations, and the explanations for these wonderful colours, patterns and shapes can be extremely fascinating as you will soon discover.

Opposite and above: Just off a tiny dirt track crossing the desert in Gujarat, western India, a Sykes's Nightjar made its nest at the base of a small bush. I wondered why my guide stopped and stepped out of the car to seemingly circle aimlessly around several bushes. Finally, he stopped and pointed, but it wasn't for several minutes until I spotted the nightjar pressed into the grass. Like many animals that are extremely well camouflaged, this nightjar will not move until a threat is close by, sometimes only a few centimetres away. Nightjars often close their eyes when approached, a wise strategy as their black eyes are often the first thing you'll notice before putting the entire shape together and you finally 'see' a bird.

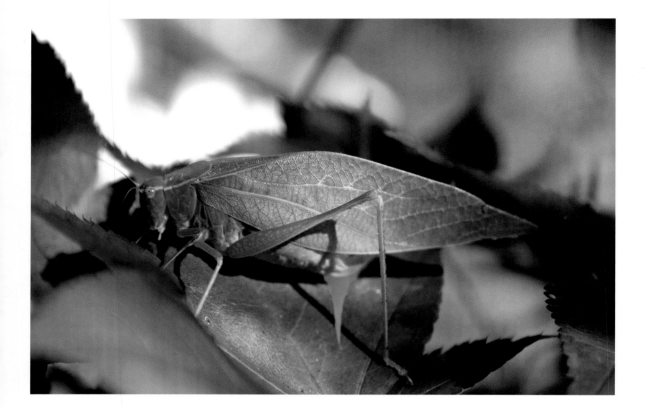

Above: The shape and the pattern of this katydid's wings mimic the leaf it rests upon. Some leaf-mimics even have wings complete with holes or tears, which give the appearance of a leaf which has been tattered and chewed by the actions of other insects. Many insects that resemble leaves or flowers also move very slowly or not at all during the daylight hours to avoid detection.

Opposite: Like many species of frogs and toads throughout the world, this North American Wood Frog sits motionless on a leaf-strewn forest floor, invisible to most predators and to its potential prey until it moves. Despite the supreme camouflage, only a small fraction of the hundreds of tadpoles produced each spring will survive to breed the following year.

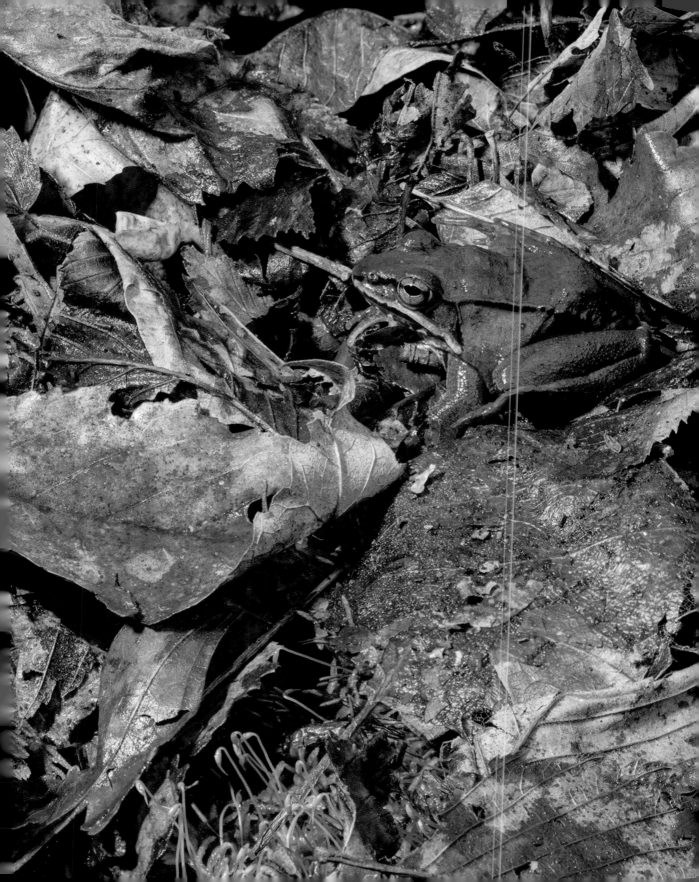

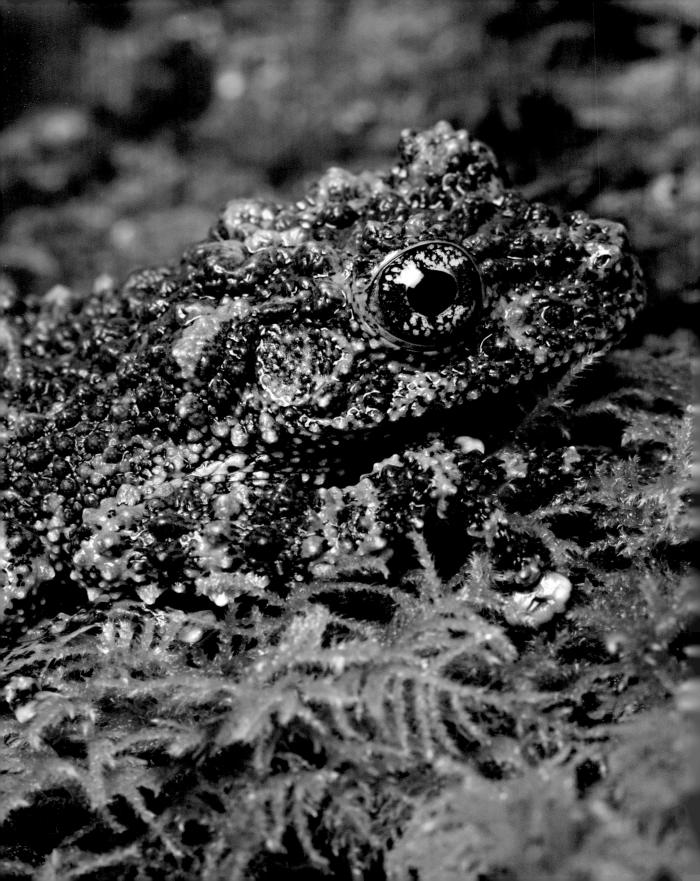

Background Matching

Perhaps the simplest form of camouflage is where an animal's coloration blends in with or matches its environment. Predators do so in order to catch prey, while prey animals blend in to avoid being eaten. In many species this protective coloration, called 'background matching', accomplishes both goals. For example, a green snake uses background matching to avoid the attention of predators such as snake-hunting hawks, while remaining undetected by its potential prey.

Some animals can match their colour to the seasons, particularly with species that live in far northern climates where there are dramatic changes between the warm summer and the cold winter. To accomplish this nifty trick, ptarmigan, weasels, Arctic Foxes, and other species rely on the photo period, the length of daylight, to trigger these moults – not the temperature or the weather as these can vary from one season to the next, or even by the day. Photo periods are a constant, but herein lies a potential threat. As summer wanes and the days grow shorter, these animals begin to shed their summer coats, gradually replacing them with white feathers or with fur that, in a few weeks, will match their new environment. Today, however, global warming may postpone the arrival of the snow, resulting in a white animal standing out conspicuously in a snowless winter landscape. Likewise, in spring, if the warm weather arrives too early and the snows melt before the animals change to their summer coats, their once superbly effective winter camouflage becomes a liability, not an asset.

Sometimes there is more to an animal's coloration than literally meets the eye. Well-camouflaged parakeets, for example, whose green plumage may match the foliage of their tropical forests so well that they seem to disappear as soon as they land in a tree, have ultraviolet properties in their feathers making them, in the eyes of another parakeet, quite conspicuous.

Across the geographical range of a species there can be tremendous variation in base coloration from individual to individual, from green to brown to black, or even white. In species that produce a large number of eggs, such as grasshoppers, nymphs of different colours may occur in the same clutch, but within a short time only those grasshopper nymphs that match their background survive. The others, more conspicuous against a contrasting background, are picked off more easily by predators. In White Sands, New Mexico, for example, there are snow-white grasshoppers that blend in perfectly with that region's gypsum sands, while in the surrounding rocky desert, individuals of the same species are grey, brown, or even black.

The Eyelash Viper – a venomous snake found in Central America – has an even odder story. This species is quite variable in coloration, ranging from a bright yellow to a near-solid green, with some individuals speckled with black or red or brown to create a very mottled appearance. Whether by intention on the part

Opposite: The aptly name Vietnamese Mossy Frog has evolved patterns and even skin textures which perfectly mimic the vegetation found in its moist habitat.

of the snake, or selection as predators pick off the more conspicuous individuals, yellow Eyelash Vipers are most often found at flowers, while green and mottled snakes hunt from the safety of leaves. In these two locations the two colour varieties hunt very different prey. The yellow phase of the viper typically preys upon hummingbirds, while the bush-dwelling green and mottled phase hunts small frogs and lizards. Sometimes the viper's prey preference is quite precise, and in captivity yellow Eyelash Vipers often ignore the frogs that their green or mottled brethren consume readily.

Background matching is often associated with other forms of disguise, including patterns or spots or departures from the 'normal' body shape to break up an animal's outline from what a predator might expect to see. Some even add on bits and pieces of living or dead material to further augment these disguises. Regardless, although an enormous variety of animals employ seemingly endless variations that incorporate several forms of camouflage, for many, background matching forms the foundation on which all of these other forms of camouflage are built.

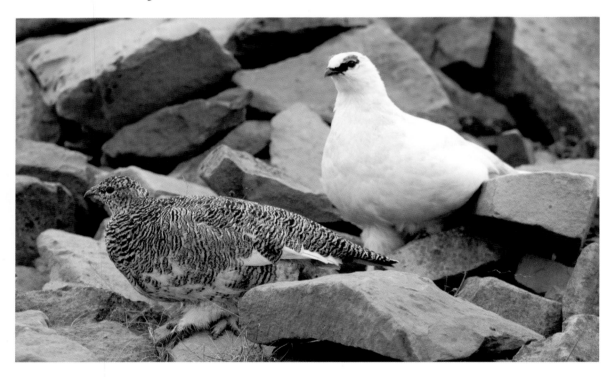

Above: In spring female Rock Ptarmigan moult into their summer plumage first, while the males maintain their white feathers for a few more weeks in order to be more visible and attractive to the females. The males make short looping flights in a courtship display, but this sexy visibility can come at a cost as it makes the males conspicuous targets for predators such as Gyr Falcons or eagles.

Opposite: In the autumn Rock Ptarmigan moult their brown summer plumage for a new coat of pure white feathers, allowing the birds to merge with the snowy landscape of their arctic and mountain tundra habitats. Although their winter plumage provides extremely effective camouflage when a ptarmigan is out in the open, these birds spend the majority of their time in winter huddled in groups in snow banks and drifts in order to conserve both warmth and energy.

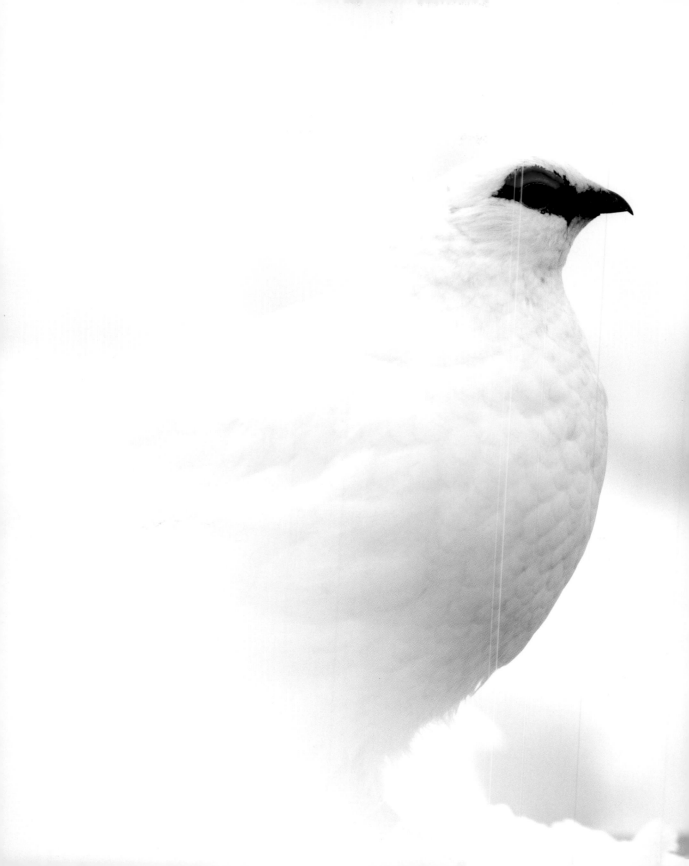

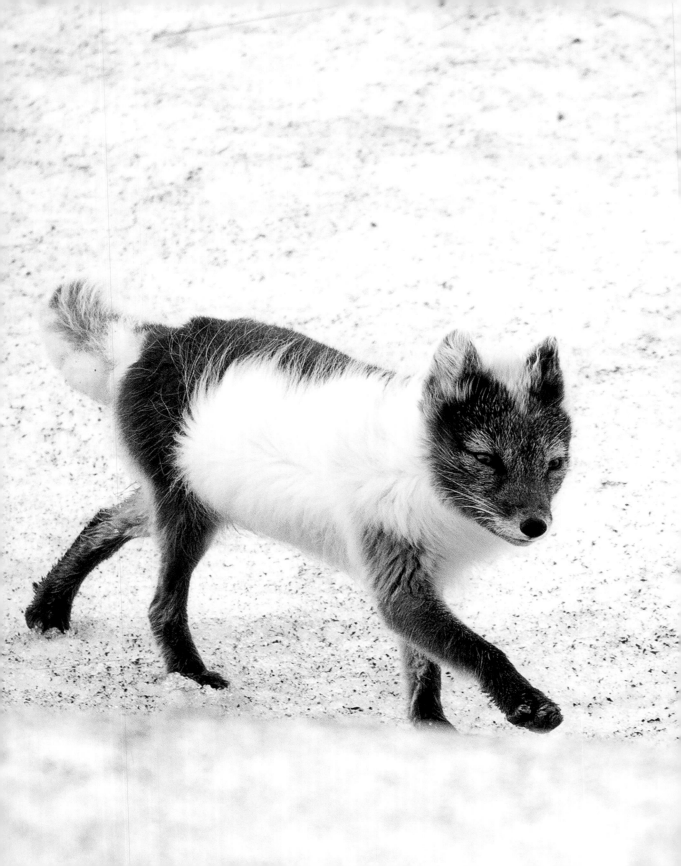

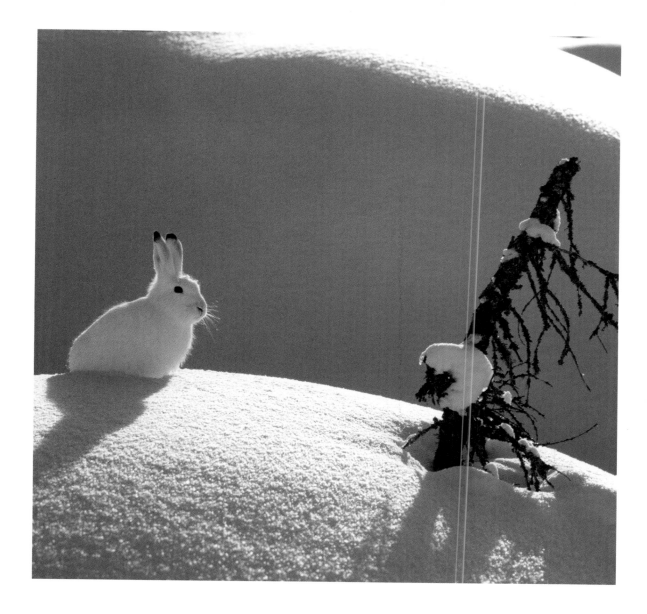

Above: Although the Arctic Hare is conspicuous in this image, when resting beneath a stunted spruce or nestled into a thicket of willows it becomes practically invisible. While humans may be lucky enough to spot a motionless hare by recognizing the darker eyes, ear-tips and nose, most predators cannot, and only movement will betray the hare's presence to the predator.

Opposite: In winter the Arctic Fox is pure white, but by summer the white fur is moulted and replaced by a coat of grey or bluish-black. During the transition from one coat to another the fox is poorly camouflaged, although for this fox, which was raiding a colony of eider ducks in Svalbard for their eggs, the contrasting tones of light and dark simply did not matter.

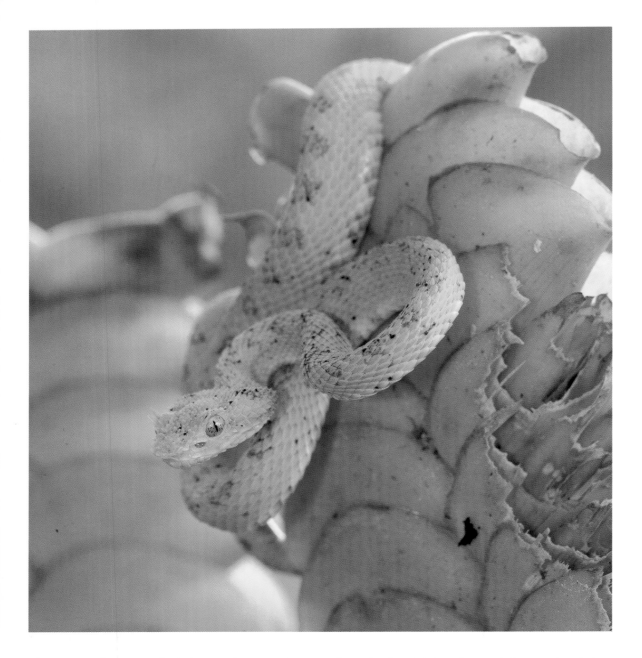

Above: Central American Eyelash Vipers have a wide range of morphs, from bright yellow to dark green, but their coloration is only effective if the snake waits in ambush on vegetation that matches. Yellow morphs of this pit viper often rest on or near to flowers, where they wait in ambush for hummingbirds.

Opposite: Beak buried down into a flower or busy plucking at leaves or fruit, the vivid green feathers of many species of parrots and parakeets, like this Yellow-chevroned Parakeet in Brazil, disappear against the background of the surrounding foliage. While both groups, parrots and parakeets, often sport brilliantly coloured plumage visible to our eyes, many species' feathers have ultraviolet properties as well. To our eyes a parakeet may disappear when perched in a bracket of leaves, but its plumage may glow vividly in the eyes of another parakeet.

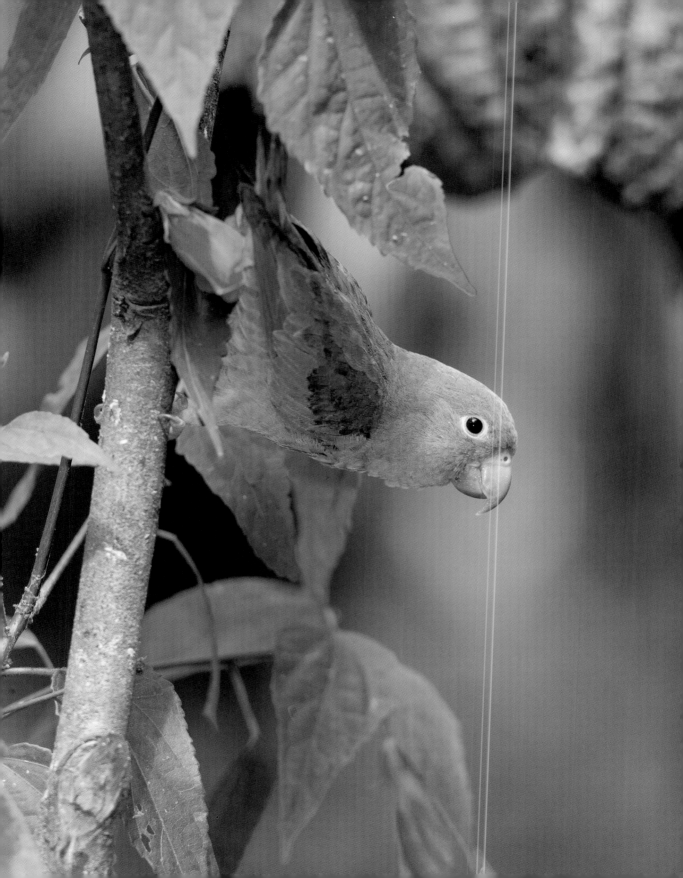

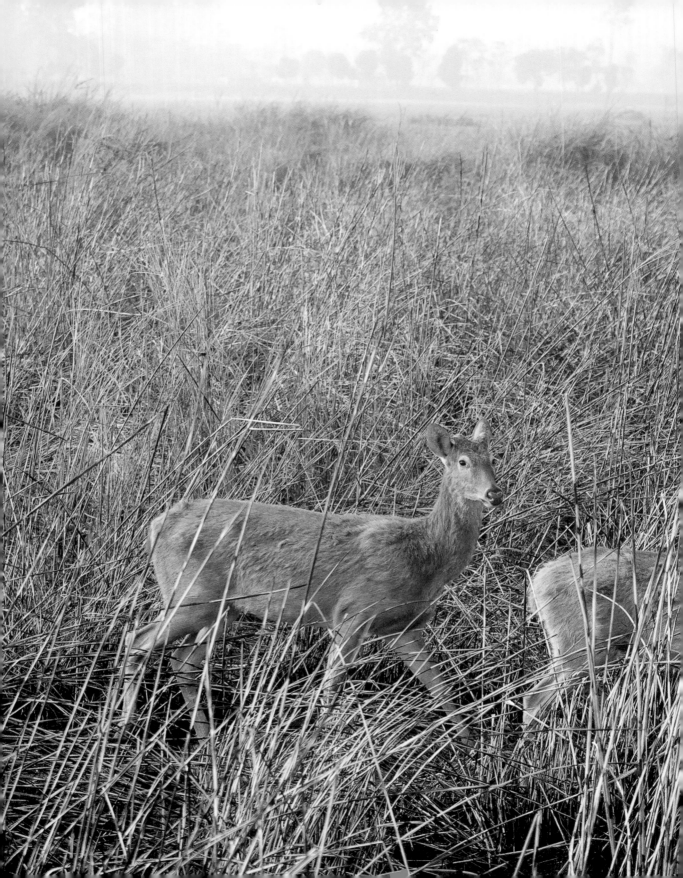

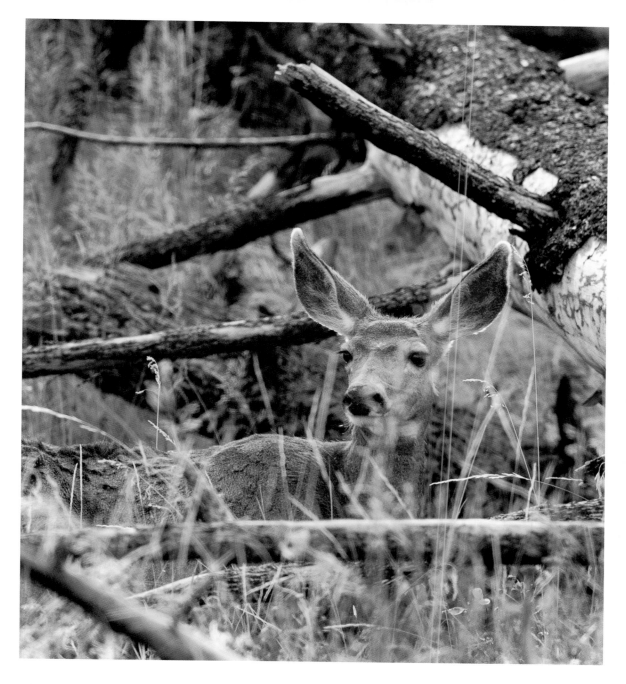

Above: In the USA, this Mule Deer is resting by a fallen pine in Yellowstone National Park. When the deer is motionless it blends in perfectly, and thus remains safe from the eyes of hunting wolves or pumas. Unless the deer flicks an ear it is likely to remain unseen.

Opposite: Many herbivores have a uniform brown or grey coat that matches their surroundings. In the dry season, when the tall elephant grass of north-eastern India turns brown, the Barasingha deer's matching pelage allows this large mammal to vanish when it steps into the vegetation.

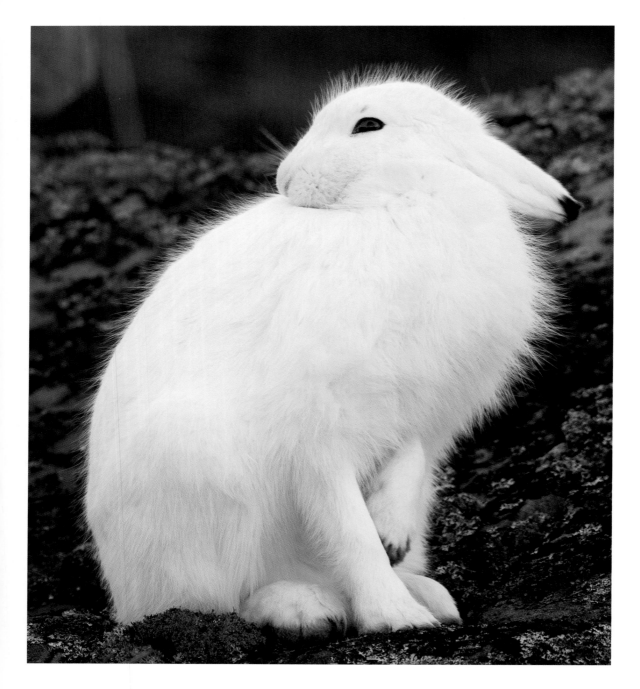

Above: Based on the photo period, the length of daylight, and the relatively constant conditions its ancestors encountered, this Snowshoe Hare in Churchill, Manitoba, Canada, should be surrounded by a landscape of snow and ice. Instead, the snow is late and the hare is exposed to predators such as foxes and Snowy Owls.

Opposite: The stone grey pelage of the Blue Sheep, or Bharal, blends perfectly with the talus and rocky slopes of its Himalayan mountain habitat. Weighing up to 70kg (155lb), the Blue Sheep is a major prey item for the Snow Leopard, with which it shares its range.

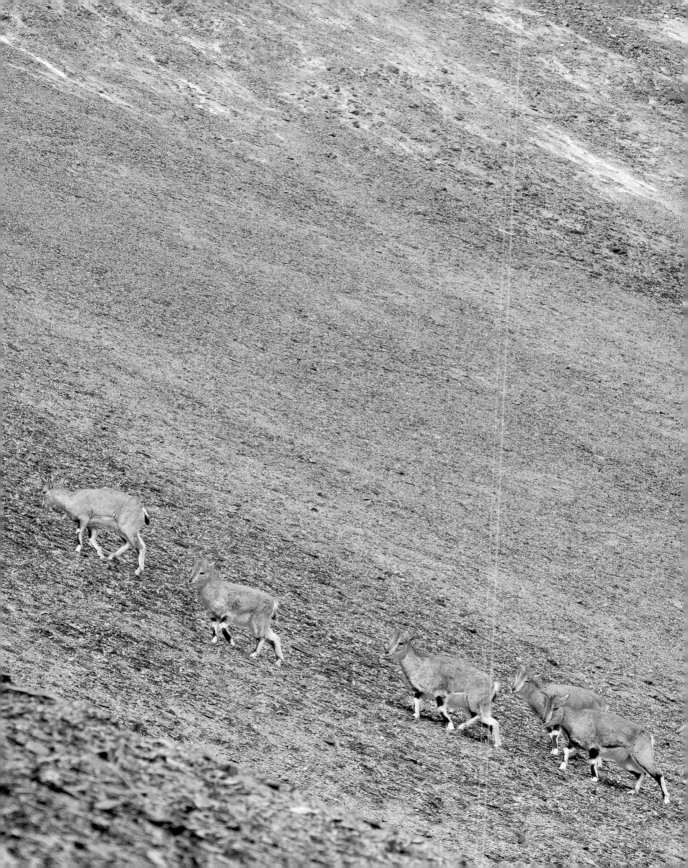

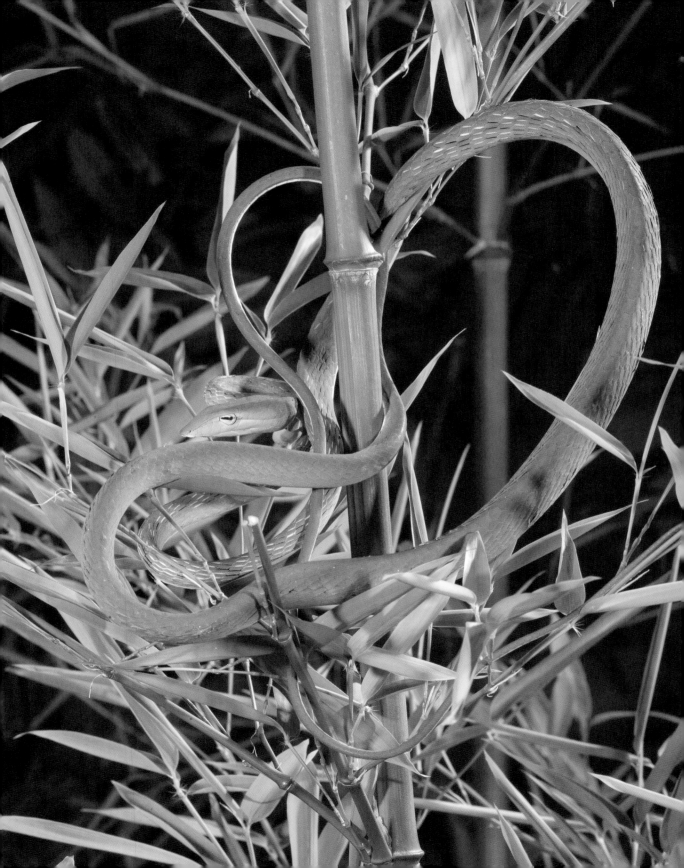

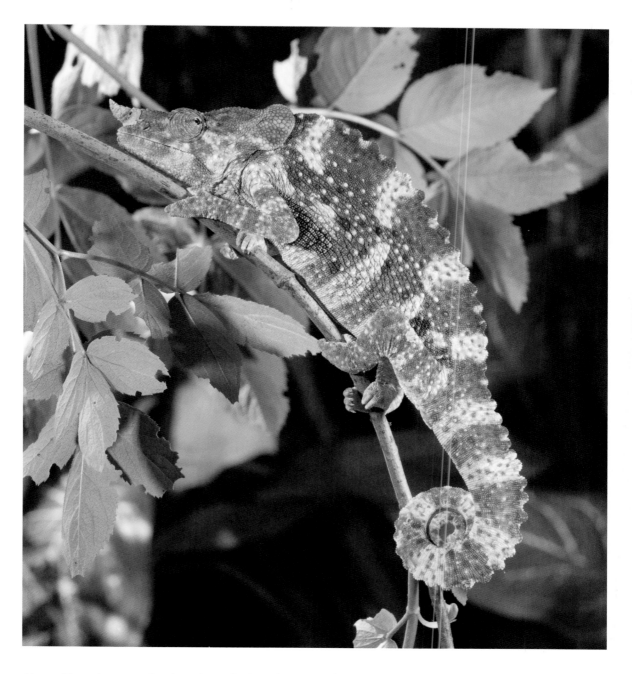

Above: Chameleons are the champions of colour changes in the reptile world. In addition to matching its background, a chameleon will also change hue according to its mood. When displaying for a mate or fighting a rival male a chameleon's colours may vividly contrast with its environment, making its presence and state of mind quite clear to any female or potential rival. The image shows a Panther Chameleon.

Opposite: Although not closely related, and found on a different continent halfway around the world, this Long-nosed Vine Snake has the same coloration and habits as the Short-nosed Vine Snake from Costa Rica, which is shown overleaf. Both species feed on lizards and treefrogs.

Above and opposite: The plain green coloration and its habit of lying motionless allow the Short-nosed Vine Snake of Costa Rica to avoid detection by larger predators such as forest hawks, and from the lizards and treefrogs this snake preys upon. Forward-directed eyes give it some binocular vision, which is essential for judging distance when the snake must span gaps in the vegetation as it seeks its prey.

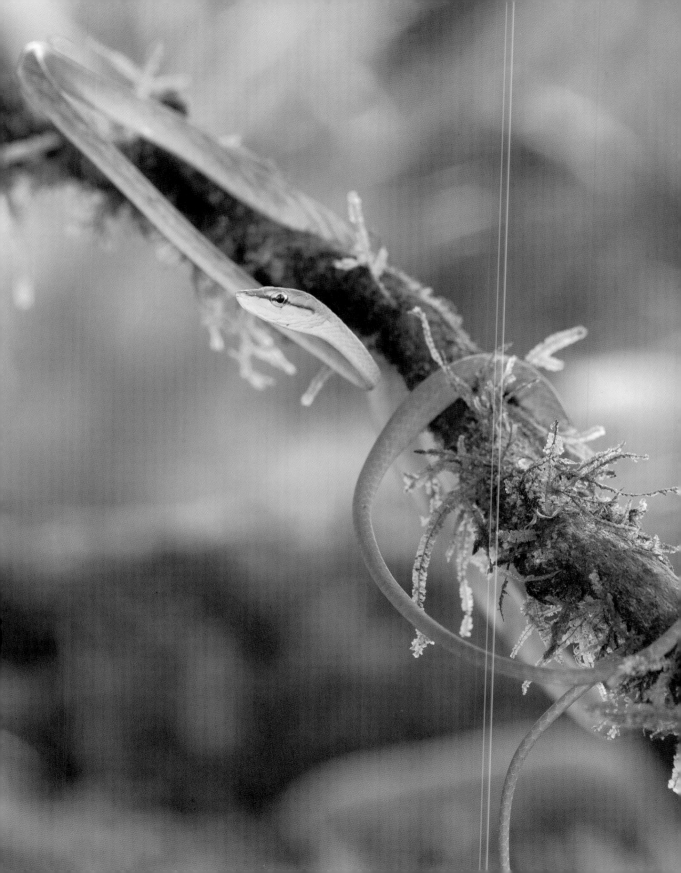

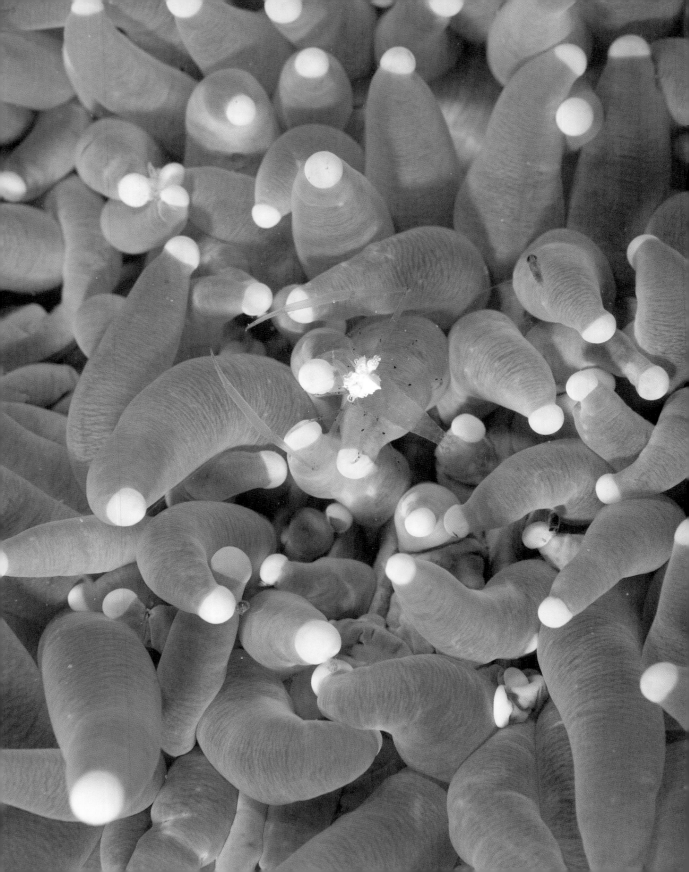

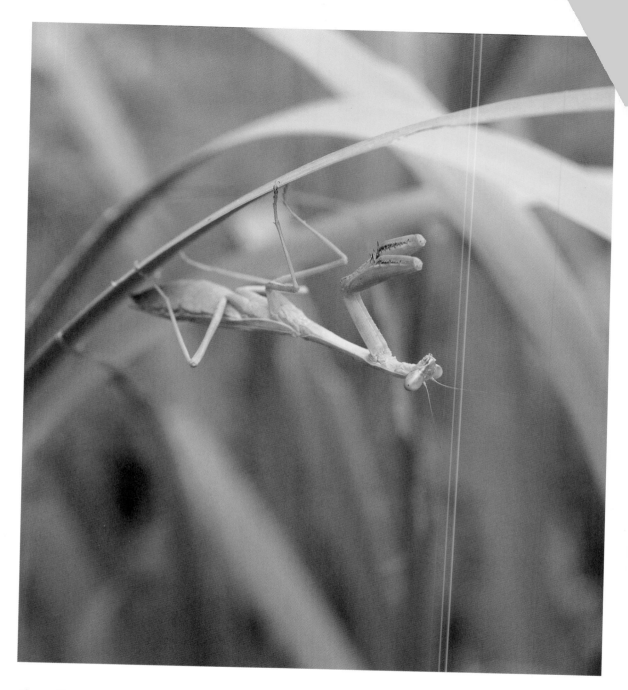

Above: The nearest meadow or field will host multiple examples of colour-matching camouflage. This praying mantis lies in wait for any passing insect that comes within reach of the two powerful forelegs it holds ready in a pose that resembles holding one's arms in prayer, hence the common name for this mantid.

Opposite: Living amidst the waving arms of an anemone this Mushroom Coral Shrimp is practically invisible. The head of the shrimp is white, matching the tips of the tentacles of the anemone, while the body is tinted to match its background, and is slightly translucent as well.

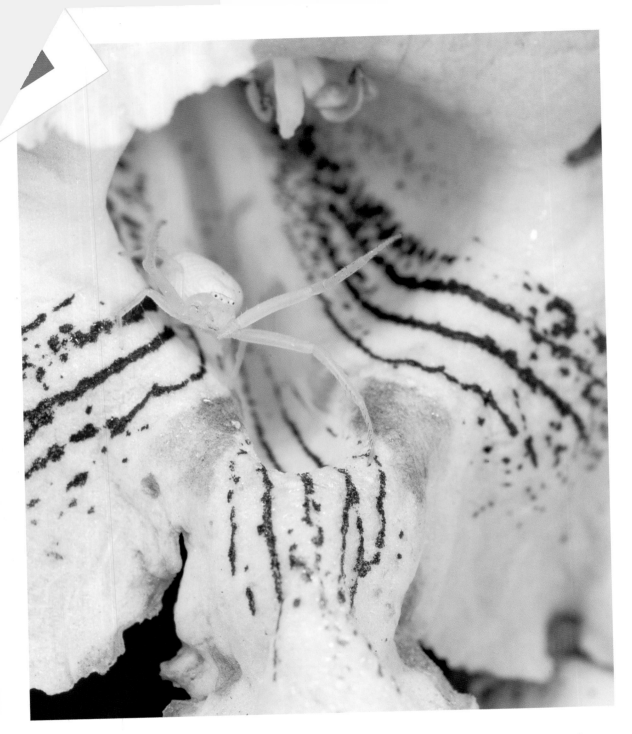

Above: These small flower spiders, or crab spiders, are found throughout the world. Matching the flower's colour the spider sits motionless until an insect arrives, whereupon it creeps in stealthily to deliver a lethal, paralyzing bite.

Opposite: Snake eels avoid predators, while waiting for prey of their own, by backing into a hole, tail first, leaving their cryptic head exposed and ready to strike.

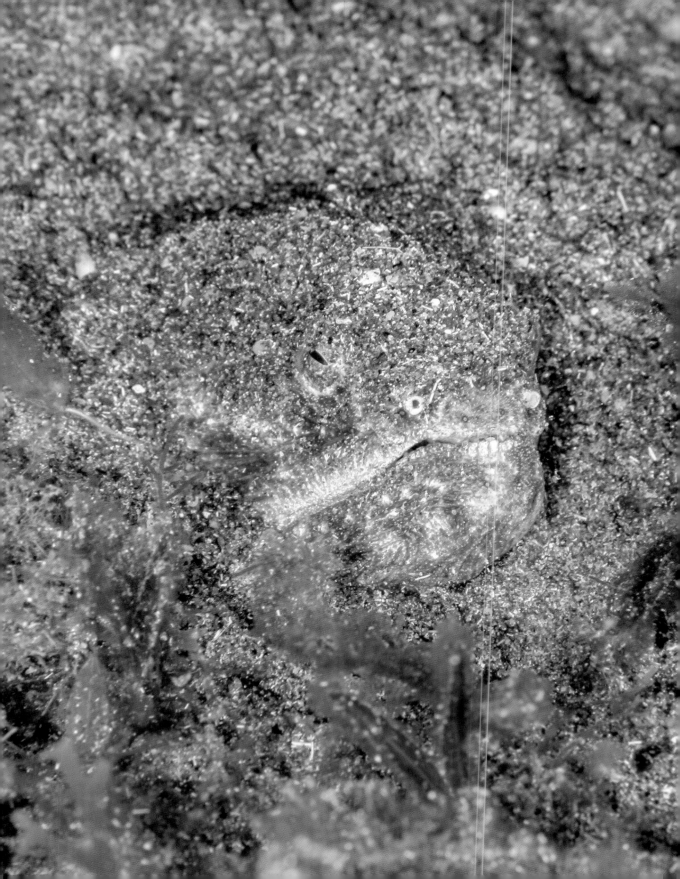

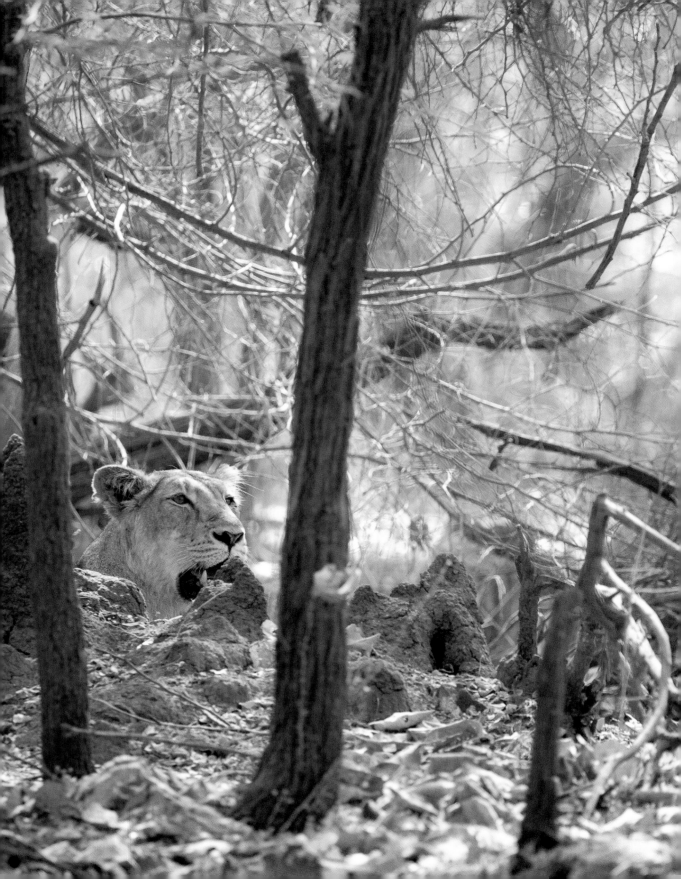

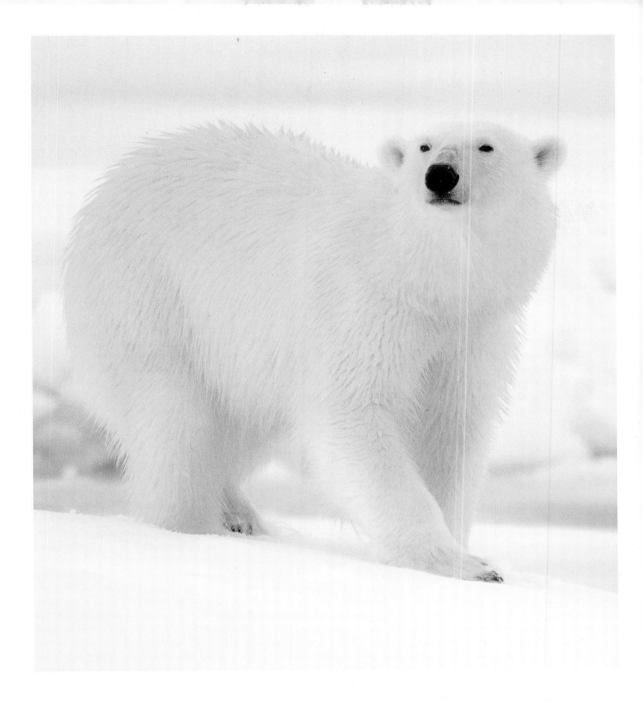

Above: While the black nose and eyes of the Polar Bear are clearly visible, these features are not readily distinguished when a hunting bear lies motionless over a seal breathing hole. Procuring any meal is a challenge in this vast, barren landscape, and bears will sit or lie next to a hole for hours waiting for a seal to pop up for a breath of air.

Opposite: In the dappled sunlight of the Gir Forest in western India, an Asiatic Lion waits for a passing Spotted Deer or Nilgai.

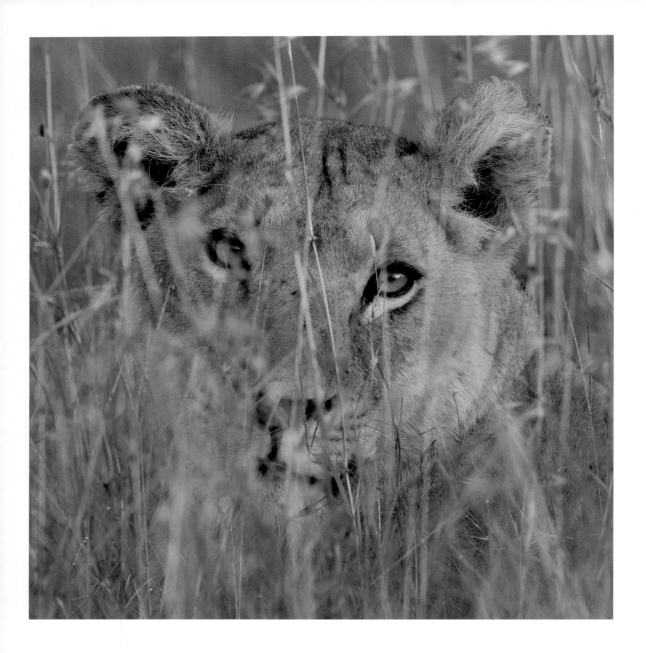

The metre-high grasses form a screen of cover for a hunting Lion, aided in its concealment by the brown seed-heads that match its coat. Although the colour of these Lions contrasts with the green of the Red Oat Grass, prey animals such as wildebeest and zebras are colour blind. Seen from their perspective, in black and white, the Lions disappear.

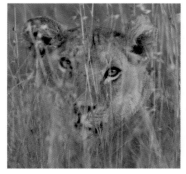

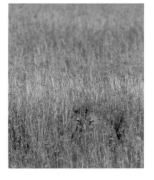

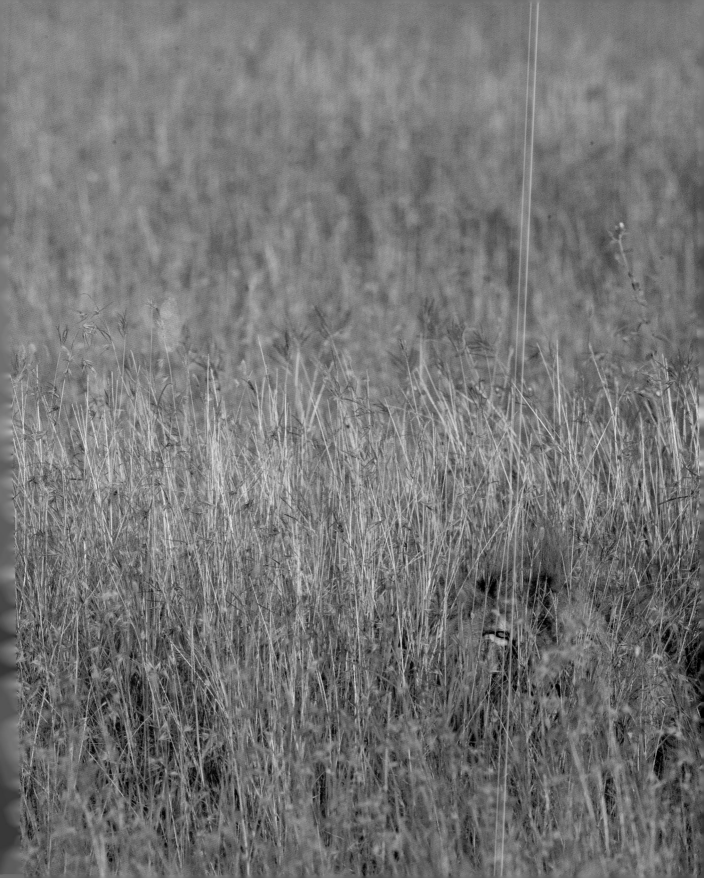

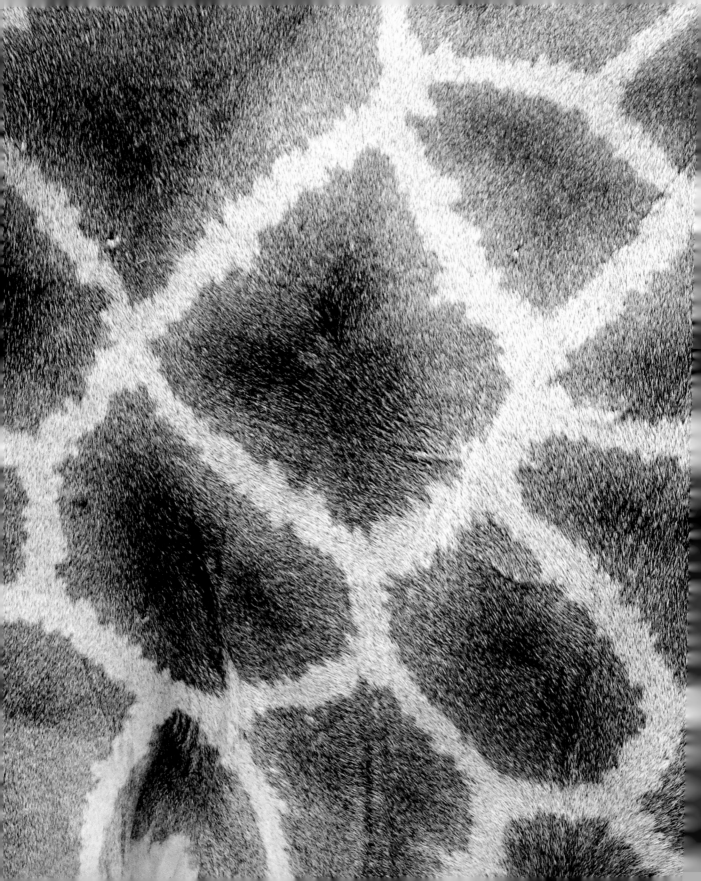

Disruptive Coloration

While background matching is an effective form of camouflage, an animal may still be recognized by its general shape or outline and thus be detected by a predator or its prey. However, when background matching is combined with distinctive stripes, spots or bars that split that base colour into sections the result effectively breaks up the form of an animal, sometimes almost to the point of near invisibility. This phenomenon is called disruptive coloration, as the otherwise smooth outline or basic shape of an animal becomes disjointed or disrupted into pieces that make no sense to the average eye. This pattern is perhaps the most widespread of all the various forms of camouflage, as it is found in both predators and prey throughout the animal kingdom.

This disruptive pattern can be as simple as the white line running down the back of a White-lined Gecko, effectively splitting the lizard's shape into two halves, or as intricate as the ornate dabs of white, black, tan and brown, that dapple the plumage of a nightjar. The appropriately named Spotted Deer, or Chital, of India's forests has white spots on its back and flanks that break up the deer's solid brown coat, while the Leopard that preys upon the deer has black spots and rosettes that accomplish the same thing.

Scientists have divided disruptive coloration into at least nine different categories, from distractive markings which draw the viewer's eye away from the animal's body outline, to maximum disruptive contrast, where markings, either light or dark, simply break up the animal's shape or overall appearance. Regardless of how many or how few different ways this type of camouflage can be divided, the results are very effective, making detection extremely difficult.

This works well for most animals but humans and some other primates, and potentially even some birds, can often detect a well-camouflaged animal, regardless of its means of camouflage. Humans do this by having what is called a search image, which is a mind's eye picture of a particular object. When that object is seen, even when unmoving, the brain still recognizes the form. Nearly everyone carries an assortment of search images in their subconscious. For example, have you ever dropped a small screw onto a carpet or lost your keys on a grassy lawn? Whether you were aware of it or not, it is quite likely that your mind had formed a search image of the item. If it did not, there is a good chance you won't 'see' the object you're searching for.

Experienced naturalists and canny locals often can spot wildlife almost immediately, while someone without a search image will struggle for minutes before they finally see the same animal. In Africa, when my wife and I are leading our photo safaris, we often comment that it takes a day or two for us to reacquire our 'African eyes,' as we mentally reboot the various search images our brains have filed away. Then, even with animals as well camouflaged as a nightjar or a Leopard, we are able to recognize that pattern and spot our subject, much to the amazement of our fellow travelers.

Opposite: The mosaic pattern on the pelage of a giraffe is a classic example of disruptive coloration.

On that same trip to Panama that I mentioned at the beginning of this book the power of a search image was vividly impressed upon me. I had been walking down a narrow road with another researcher, talking about fish, when I suddenly spun around as if I'd been pulled back by a hook. I quickly retraced my steps for a dozen feet, saying nothing and undoubtedly puzzling my companion as I hustled back down the trail. Then I saw it, a baby Green Iguana that was sitting in a thicket of leaves. My mind's search image had recognized and processed the image subconsciously while I had walked on. We had to laugh as we wondered what took so long for my brain to register what my eyes had seen!

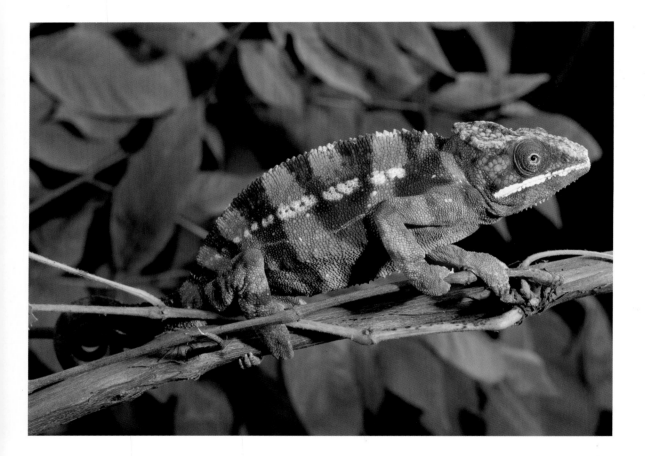

Above: The dark bands crossing this Panther Chameleon's body break it into sections, thus interrupting its outline and disguising a typical chameleon's shape.

Opposite: Pale bands break up the outline of the Wagler's Viper as this venomous arboreal snake lies in wait in vegetation for prey such as small birds and mammals.

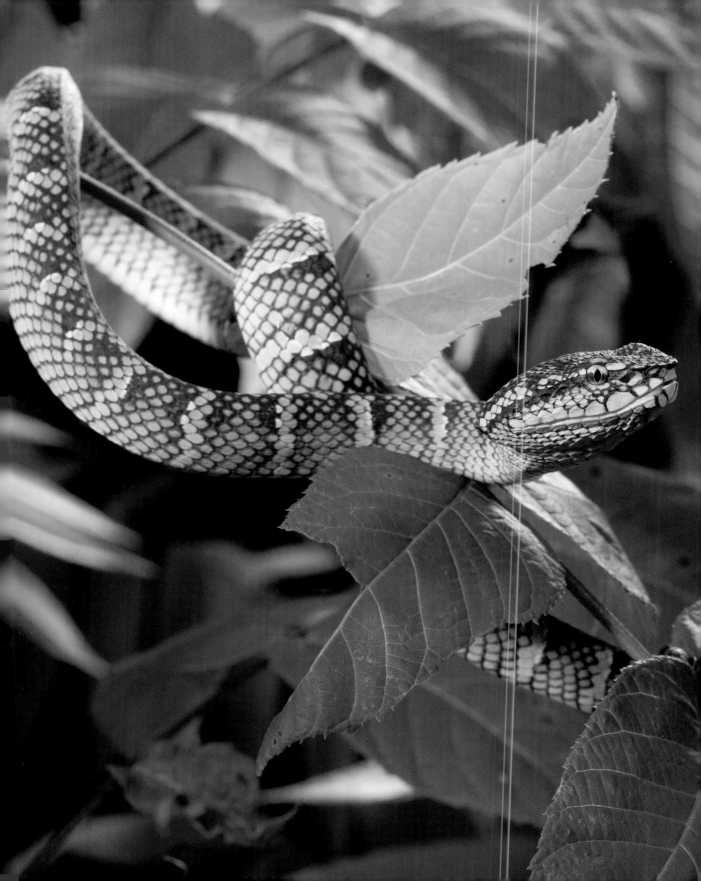

You'll have to look very carefully to see this Bengal Tiger. In fact, my park guide had to aim my telephoto lens for me before I could spot it, although in my defence the dried grassland extended much further than what is shown in this image. The Tiger is right in the centre of the right-hand page.

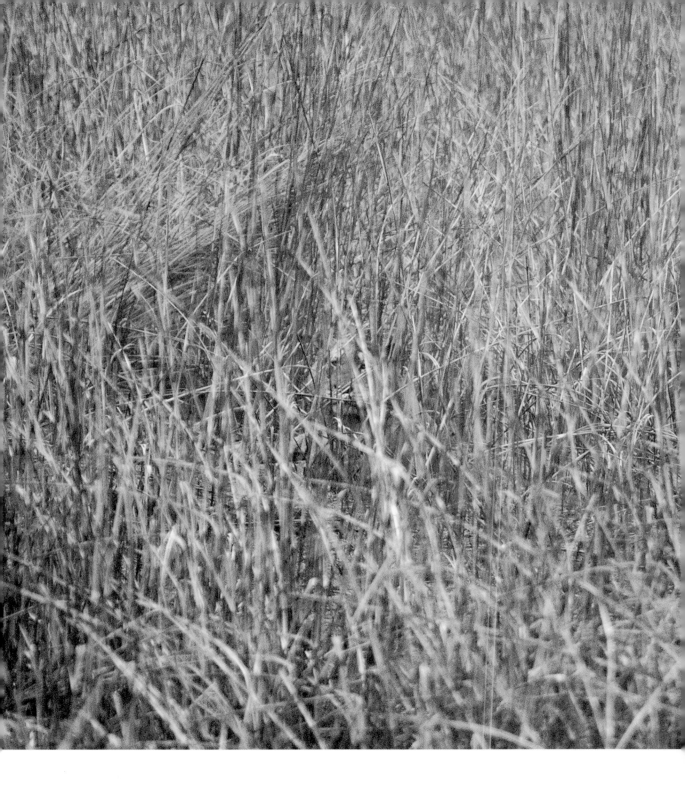

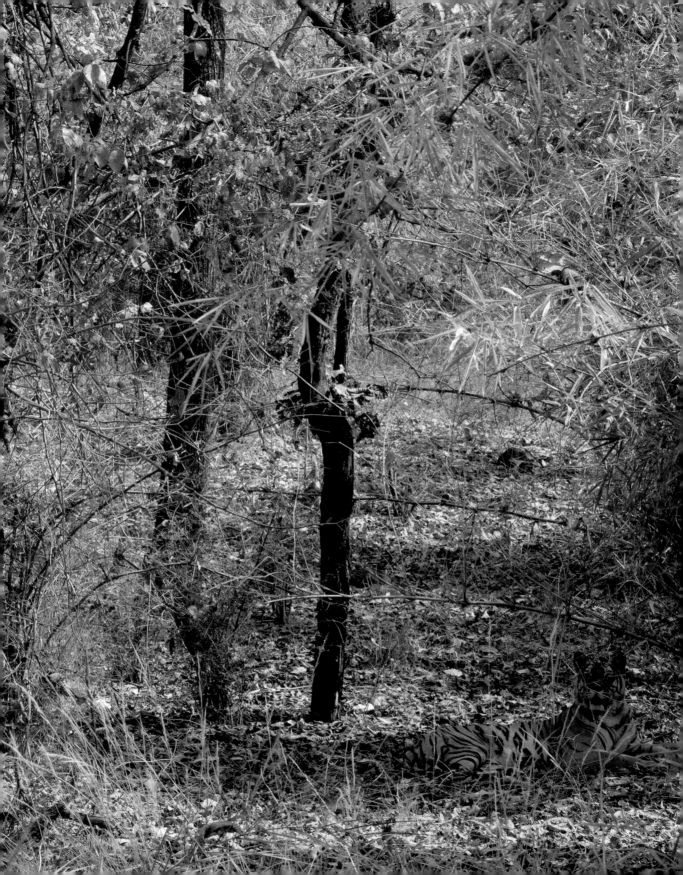

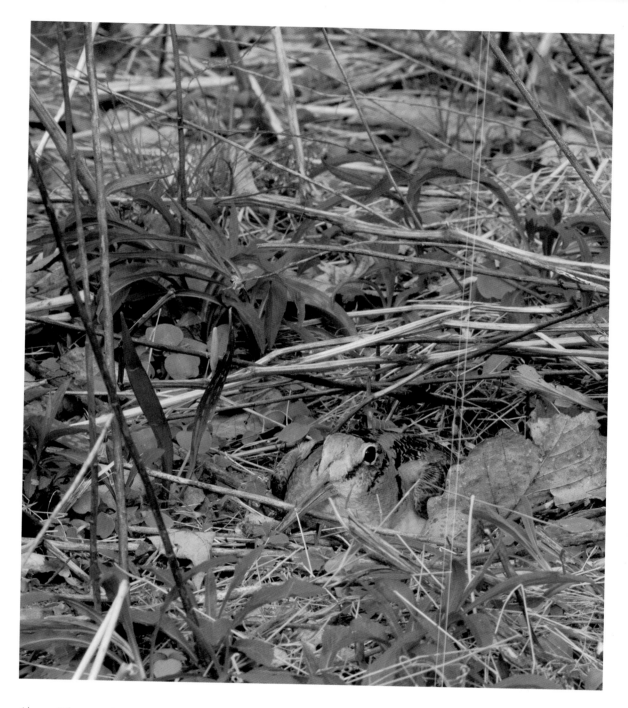

Above: When nesting, many species of cryptic shorebirds remain perfectly still, and thus unseen, even when an observer is less than a metre away. Some naturalists have even touched the tip of an American Woodcock's bill without flushing the bird, although such behaviour should not be repeated!

Opposite: A relaxed Bengal Tiger in Bandhavgarh National Park in central India practically disappears as it lay in the shade of a bamboo thicket.

Above and opposite: Nightjars are members of a wide-ranging family of birds called the Caprimulgidae, or goatsuckers, so named after the ancient myth that these birds sucked milk from goats. The plumages of these insectivorous birds are consummate examples of disruptive coloration. During the day Indian Nightjars sit on branches or rocks unnoticed, waiting for nightfall when they will hunt for insects which they capture in mid-flight.

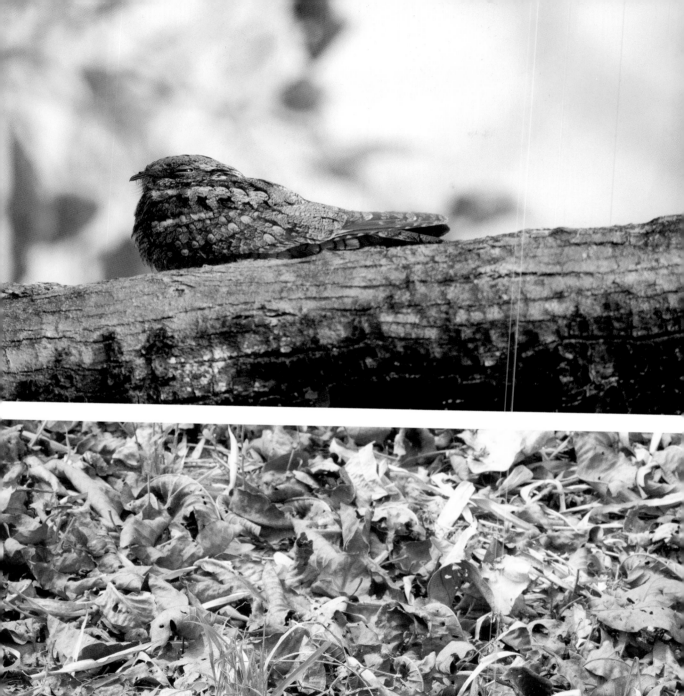

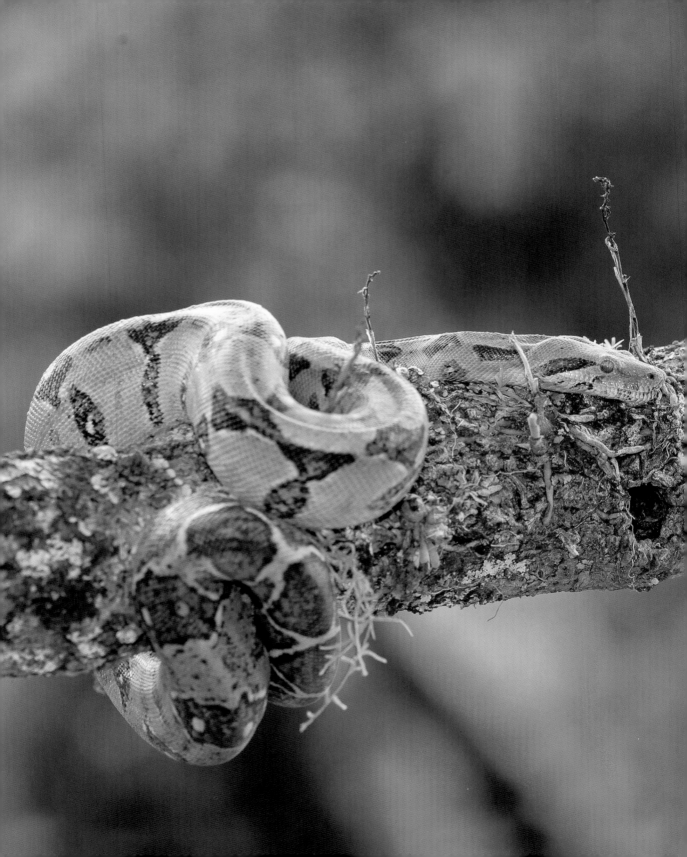

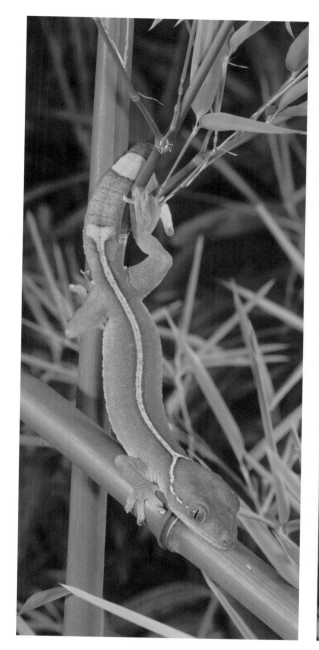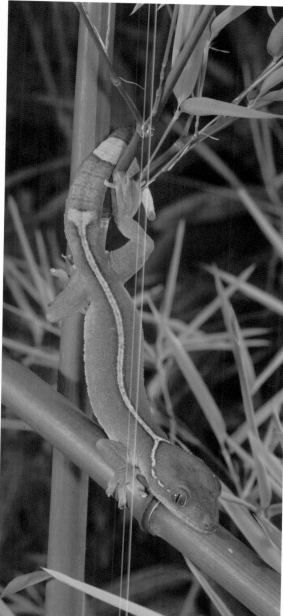

Above: The stripe running down the back of the White-lined Gecko splits the lizard's outline in two – a ploy meant to confuse the search image of most predators. While the gecko's colour does not match the bamboo, it doesn't need to as White-lined Geckos are active at night when colour vision plays no role. In a dimly lit black and white world, the stripe and the basic colour work quite well.

Opposite: Like most snakes the Boa Constrictor is an ambush predator. It utilizes a variety of habitats, and may be seen (if it can be found) in trees or on the ground. Its mottled pattern blends in perfectly with a variety of backgrounds.

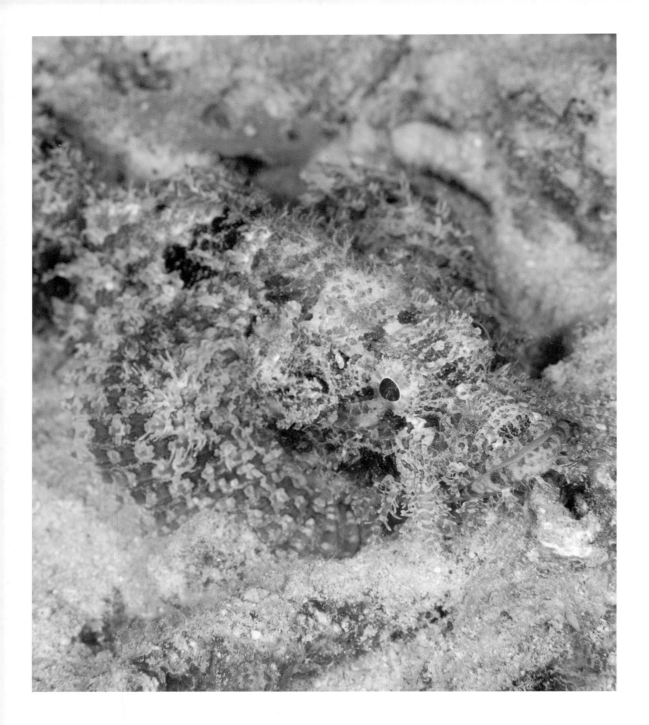

Above: With flanges and fins spread out widely, and its entire body speckled with dots, spots and lines, this scorpionfish's outline blends in to the sandy ocean floor. Only its black eyes betray its presence to a human observer.

Opposite: Wire Coral Crabs practically vanish as they sit tightly upon a strand of coral. The colour of these crabs varies according to the coral upon which they are hiding.

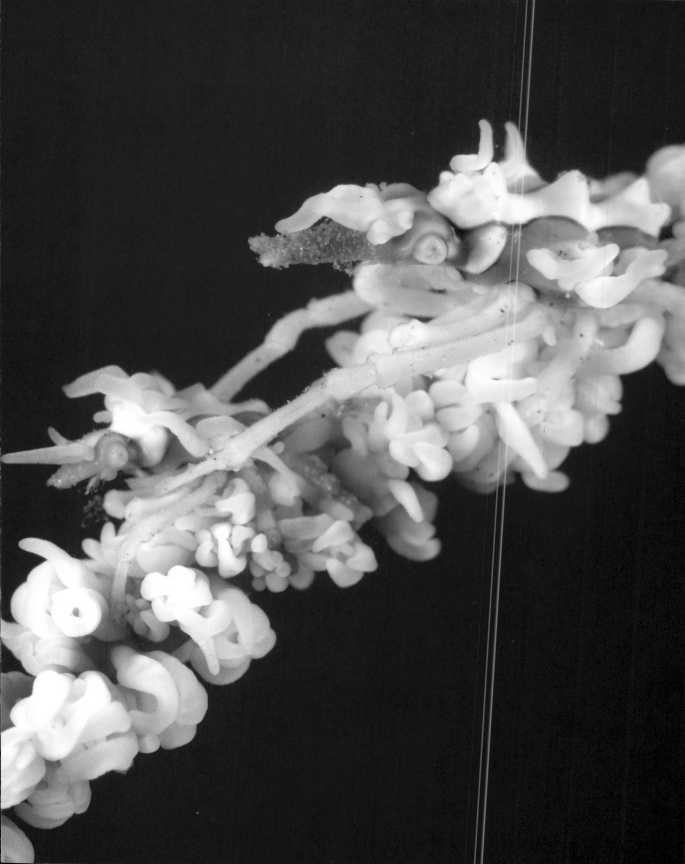

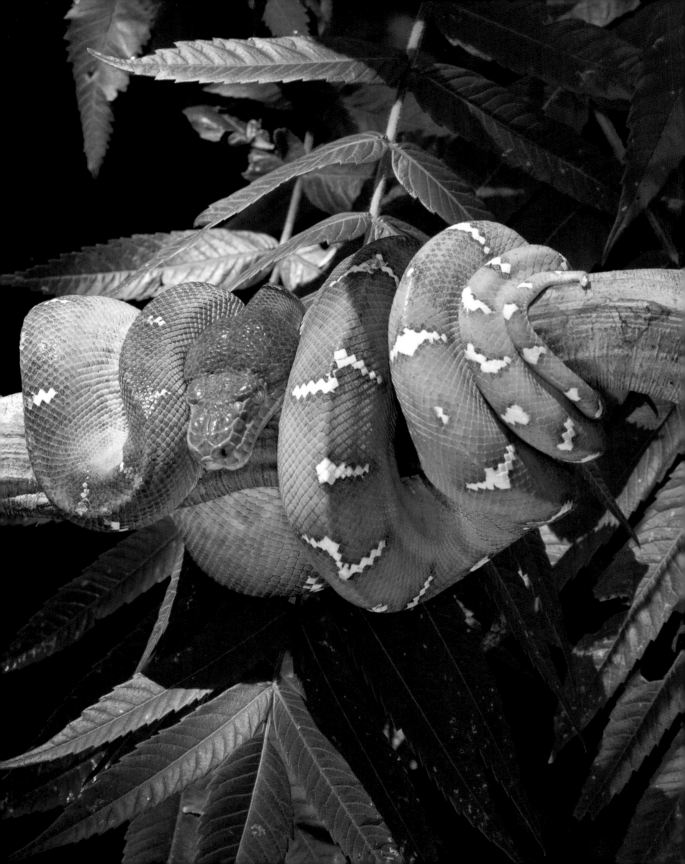

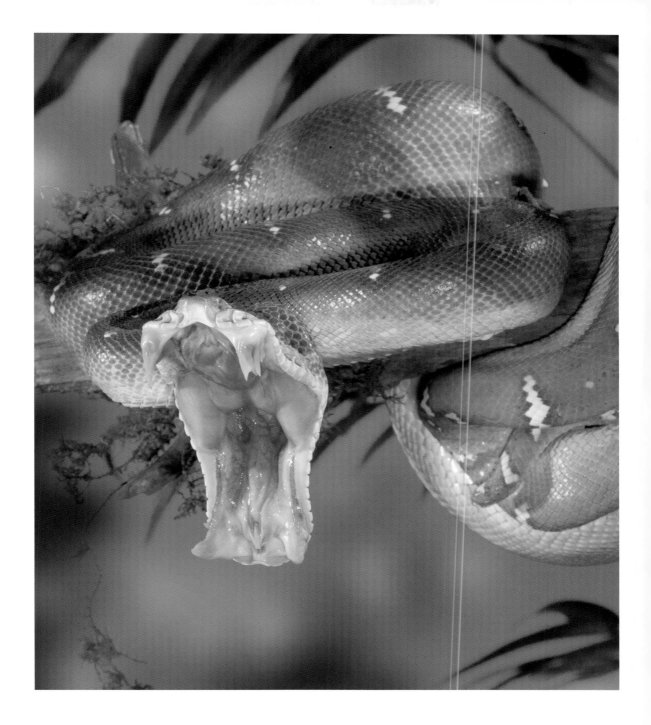

Opposite and above: The light stripes crossing the otherwise uniform green of the Emerald Tree Boa mimic the specks and strips of light filtering through the leaves in a jungle canopy. These snakes spend much of their time wrapped in a tight coil upon a vine or limb, waiting for a passing bird or mammal. Although non-venomous, the boa's long, sharp fangs act like fish hooks, and any passing bird, bat or squirrel is likely to be snagged.

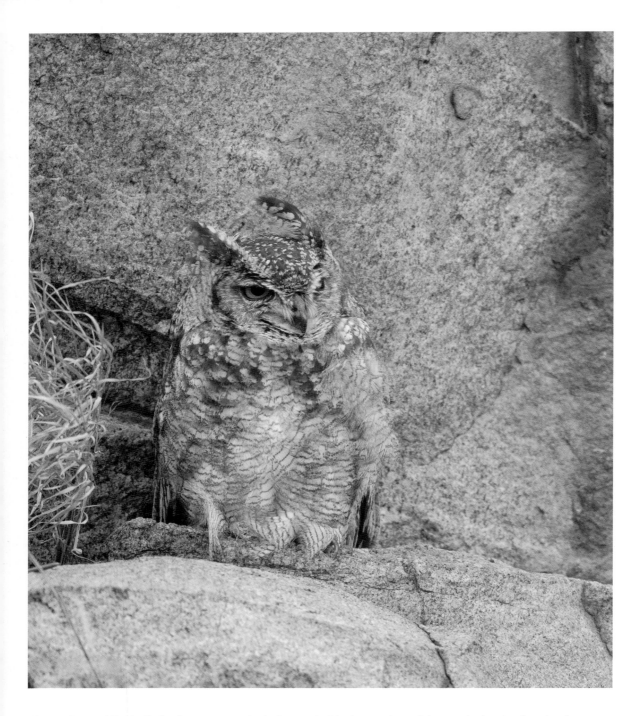

Above: Spotted Eagle Owls often roost on the ledges or inside the crevices of the granite kopjes that dot the Serengeti's sea of grass. Unless disturbed by birds, Lions, or a tourist vehicle, the owls remain unmoving until dusk when they begin to hunt.

Opposite: The vermiculation and barring on the feathers of the Mottled Wood Owl match the interior of this cavity in a broken stump where the owl has made its nest.

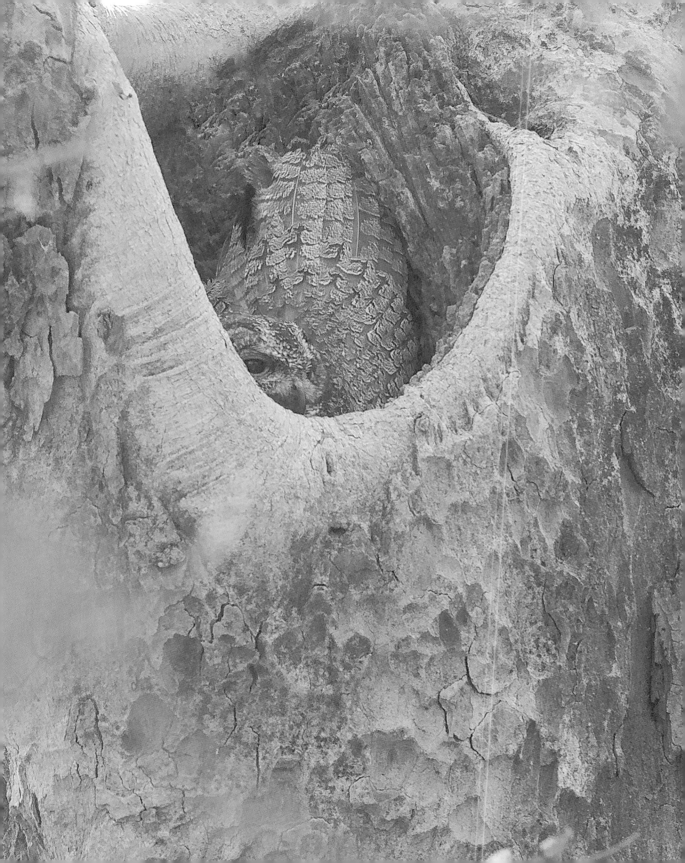

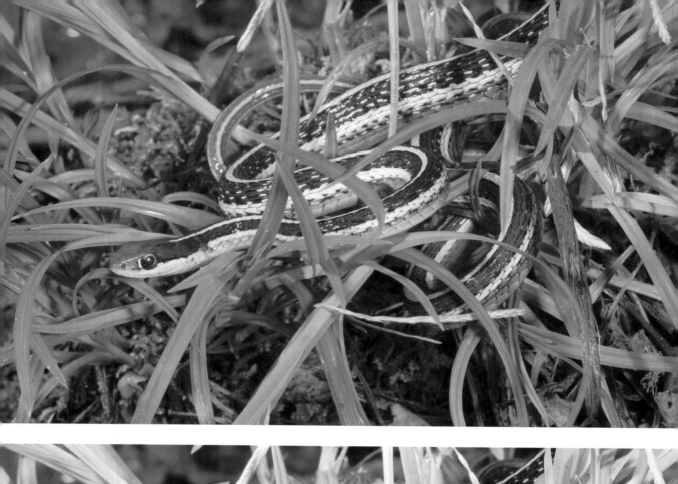
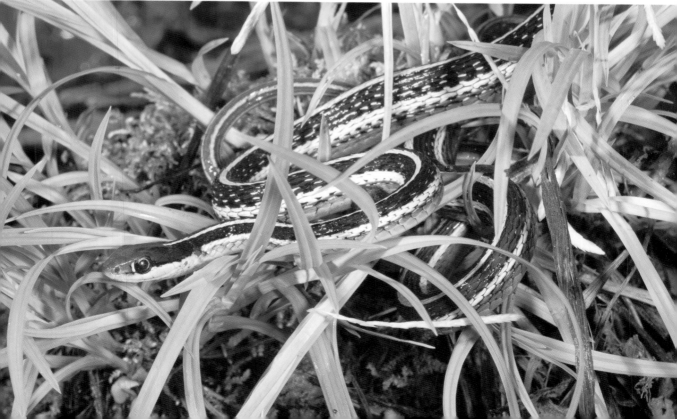

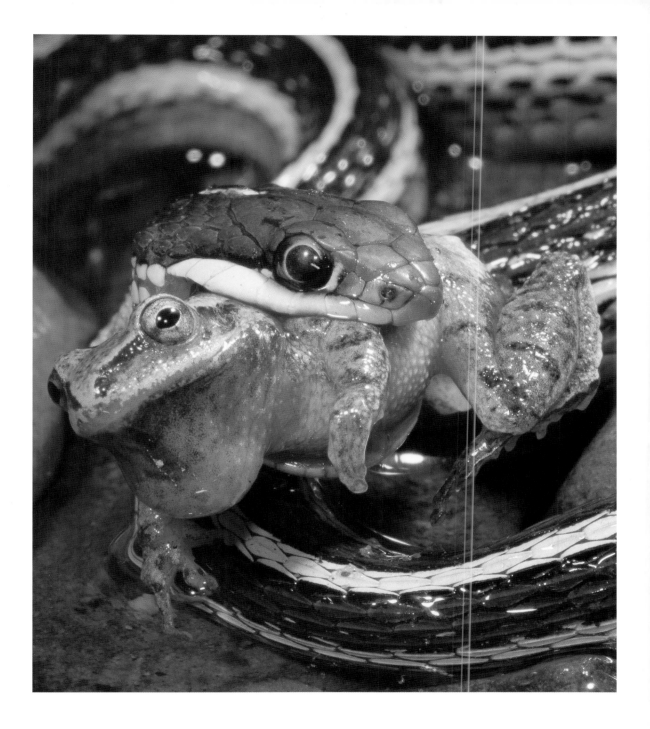

Opposite and above: Many snake species are striped, with the pattern serving to divide the animal into halves or thirds and thus breaking up its complete outline. While the Ribbon Snake's pattern seems somewhat striking to our eyes, most predators see in black and white, and thus the snake's camouflage appears quite different. Ribbon Snakes hunt in wetlands, capturing prey like this Spring Peeper.

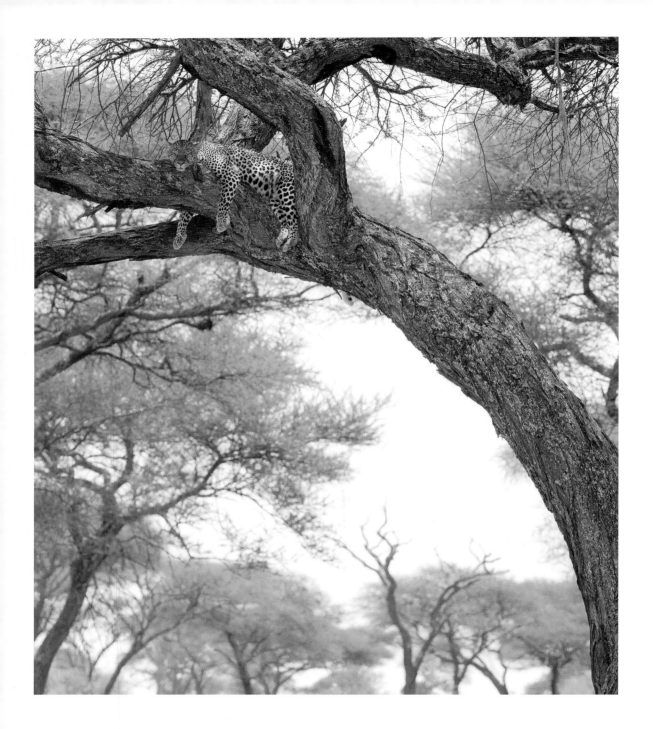

Above and opposite: Leopards are the most widespread and adaptable of the big cats, and their spotted coats seem to blend in with every habitat, be that desert rock outcroppings or leafy jungles. Leopards are frequently found in trees, which they use for resting, storing captured prey, and as hunting outposts. In the centre of the photo opposite there is a Leopard, and the same animal is shown in close-up in the inset picture.

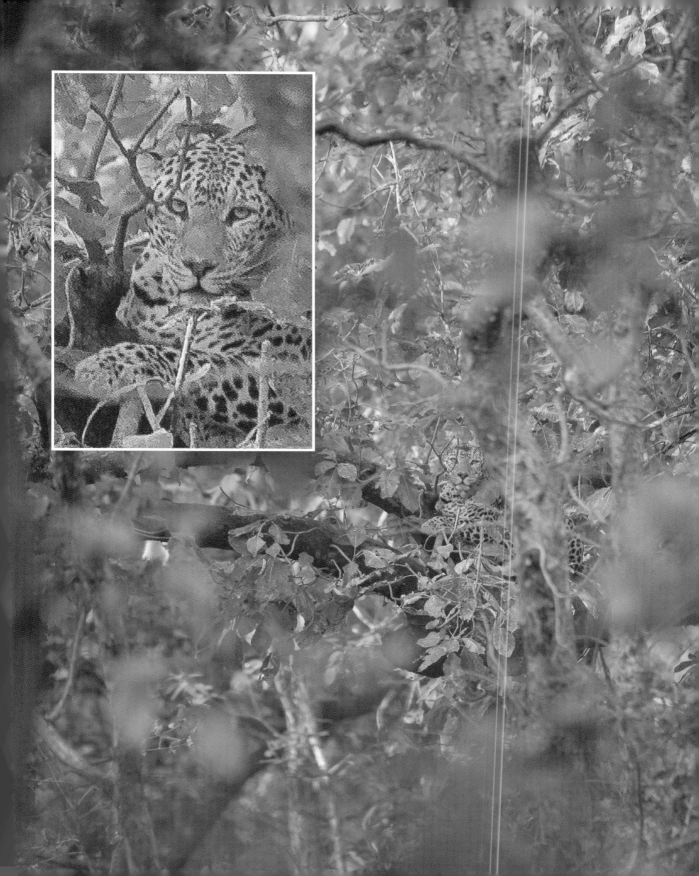

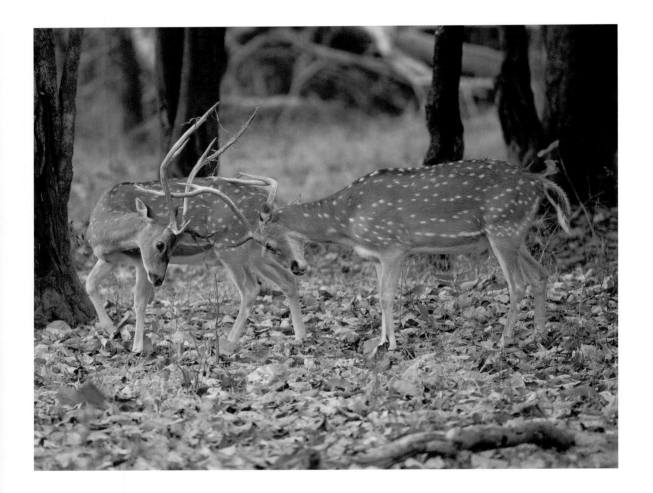

Above: Many species of deer have spots as fawns but most lose these spots as the animals reach adulthood. Spotted Deer, widespread in the forests of India, retain their spots throughout their life. The spots do not break up the deer's outline but instead draw the eye away from its overall shape. Standing or lying down among a carpet of dead leaves, Spotted Deer are quite easy to miss.

Opposite: Several thin, white stripes on an otherwise neutral greyish coat break up the Greater Kudu's body shape, merging it with the brush of its semi-desert habitat.

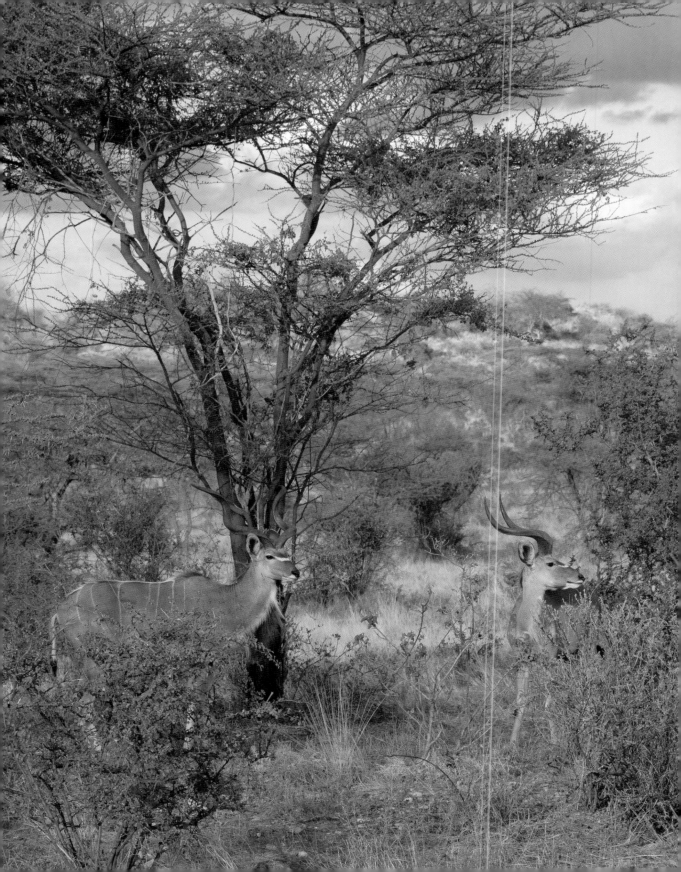

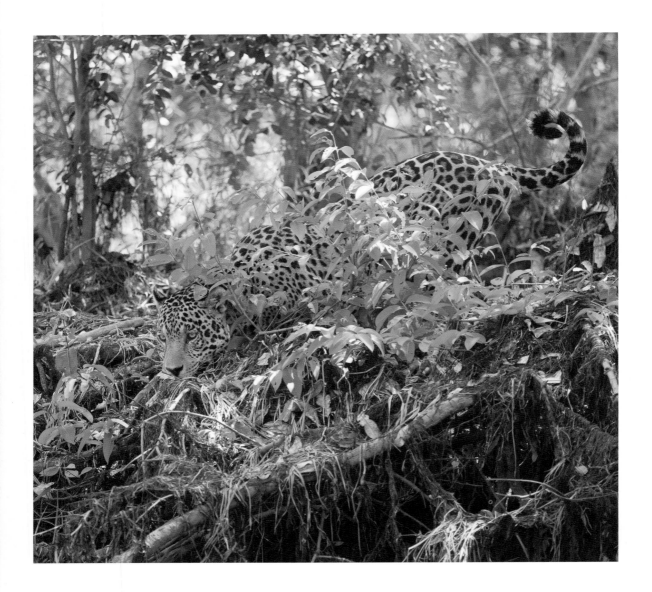

Above and opposite: Whether the Jaguar stalks through brush or marshes, its dappled, spotted coat blends in well, enabling the cat to make a short rush at its wary prey. In Brazil's Pantanal, Jaguars hunt the shorelines of rivers and quiet bayous for caiman, iguanas, and their favorite prey, Capybaras.

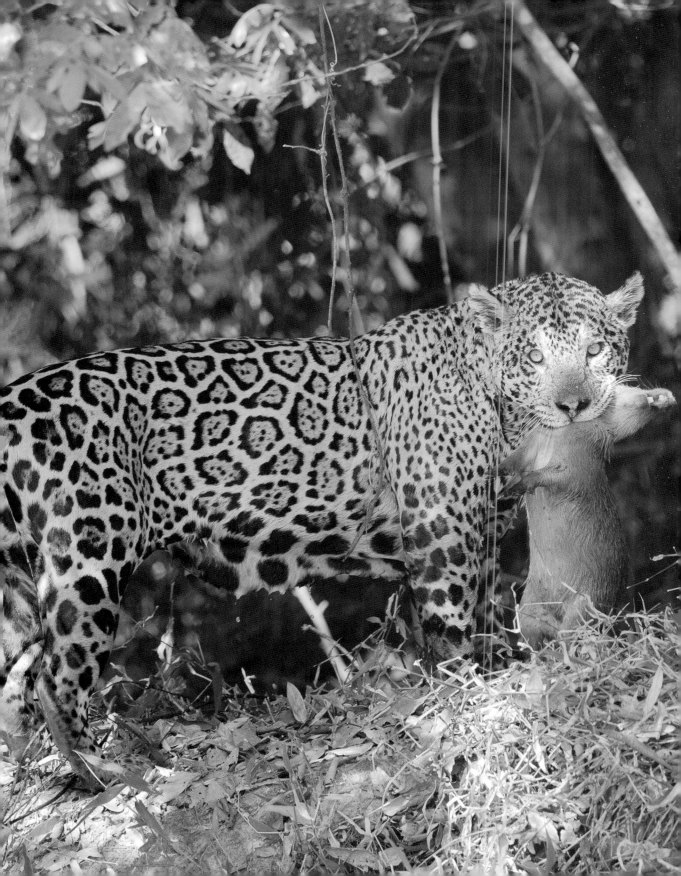

Countershading

I f you've ever had a clear, full view of a Leopard or a Tiger you may have wondered why an animal so vividly patterned with what we now know as a disruptive coloration has a white or whitish belly? It doesn't seem to make sense, especially if you're looking at one of these big cats in a zoo. If you explore a little further, you'll find that animals as diverse as various species of mice and deer, frogs and snakes, and innumerable others, all have white or pale bellies, which seem to contrast with patterns that often make the animal quite difficult to see.

As odd as this may seem, these white bellies comprise another form of camouflage. It is called countershading, where the upper, or dorsal, surface, the area exposed to the sun or to light, is darker than the lower half (the belly or ventral surface), which is a paler shade. While these odd white bellies may seem conspicuous when seen out of context, outside of the animal's natural habitat, in the wild these light areas help to reduce or to eliminate shadows. Light bellies reflect light, and thus the shadow that an opaque object may cast is softened or reduced, resulting in a surface that seems flat and not three-dimensional.

A Tiger or a Leopard standing upright might seem conspicuous with its white belly visible, but when that same cat is pressed low to the ground its outline seems to merge with its surroundings, as the belly and the substrate it is lying on become one. Coupled with stripes, spots, or even a plain brown or grey coat, as a deer, mouse or squirrel might have, telltale shadows disappear and with them so does the animal.

Some aquatic and marine creatures employ countershading in a slightly different way. While the pattern is certainly two-toned, and thus fits the definition of countershading, sharks and dolphins, penguins and puffins, trout and minnows, to name just a few, all use countershading in much the same way as we've discussed with background matching. In these examples, their dark backs blend in with the water or the substrate when seen from above, while when seen from below against the bright water surface, the white bellies blend in with a bright sky. For an ocean-going fish, this countershading provides protection from above, from eagles and pelicans, and from below, from bigger fish, dolphins and sharks.

While we're at it, there is yet another form of countershading, called 'reverse countershading', and this achieves the exact opposite of camouflaging an animal. In reverse countershading, the animal actually stands out, quite conspicuously, as the ventral surface is dark or black and the dorsal surface is light. Skunks, with their distinctive stripes or entire cape of white, are prime examples of this, but the less well known African Zorilla and the bad-tempered Honey Badger are two other examples. In all three, their distinctive and conspicuous coloration serves as a warning, as all have foul scent glands, and Honey Badgers can also be a formidable adversary if confronted. In these animals, then, reverse countershading acts not as camouflage but as a form of warning coloration, also known as aposematism, to alert potential predators to keep away.

Opposite: A close-up of a Tiger's flank, showing countershading with darker orange above and paler whitish below.

One final aside, but an interesting one. Baby Cheetahs are by no means formidable animals to deal with and instead, quite the reverse is true. For their first few months baby Cheetahs are quite vulnerable to any number of predators, and their coloration protects them in some wonderful ways. Baby Cheetahs have long fur that helps the cubs blend in with the tall grasses of the savannah, at least when they are hunkered down and still. But movement catches a predator's eye, and that's when the seemingly contradictory coloration of a baby Cheetah comes into play. The coat of a baby Cheetah is another example of reverse countershading, as the baby has long whitish-grey fur on its dorsal surface, and dark fur on its ventral. Seen from any distance, a baby Cheetah could be mistaken for a similar-sized Honey Badger – an animal that most predators would rather leave alone. In this case, this reverse countershading is an example of still another form of coloration – mimicry – an adaptation used by many potentially vulnerable animals to resemble something more dangerous.

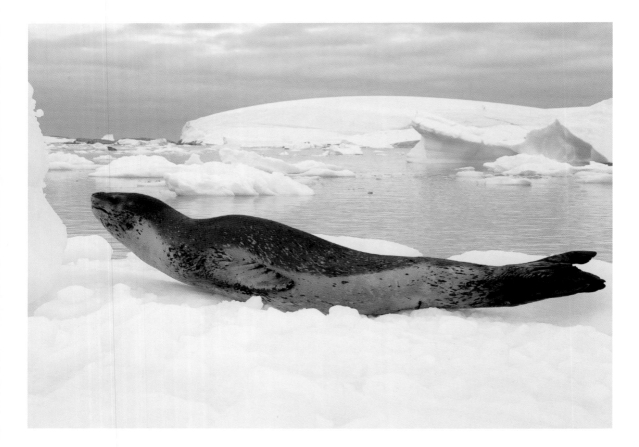

Above: On an ice floe in the Gerlache Strait on the Antarctic Peninsula, a resting Leopard Seal is quite conspicuous. As one of the top predators in its range this seal has little to fear. It hunts other seals, penguins, and fish, and like its namesake, the Leopard, uses countershading to elude the attention of its prey.

Opposite: The light underside of the Brown Vine Snake disguises its outline from below, while the thin dark eye-stripe helps to split the shape of the head in two. Although capable of gliding through its arboreal habitat quite rapidly, this snake normally moves along at a slow and steady pace, quite literally a crawl, to avoid detection.

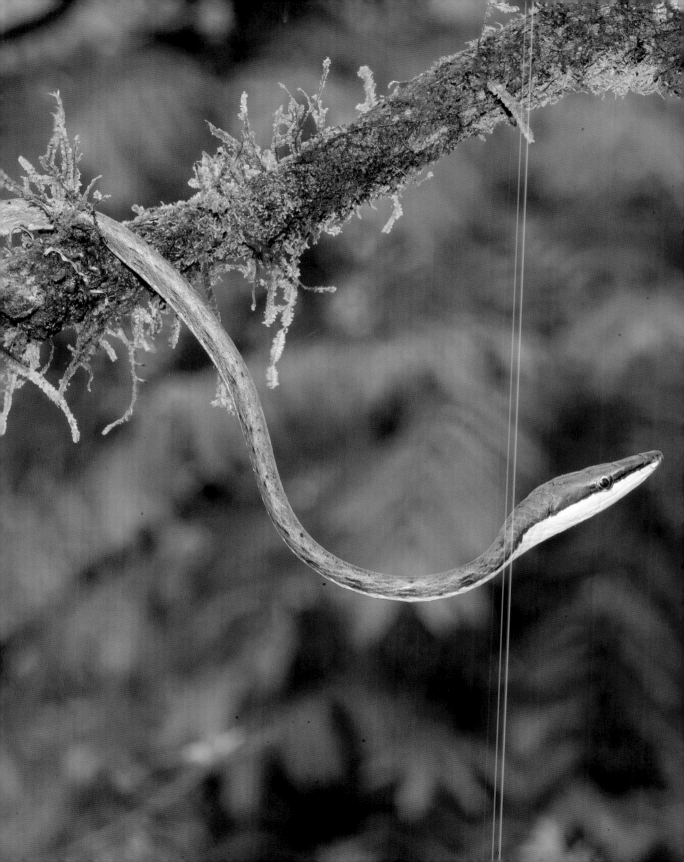

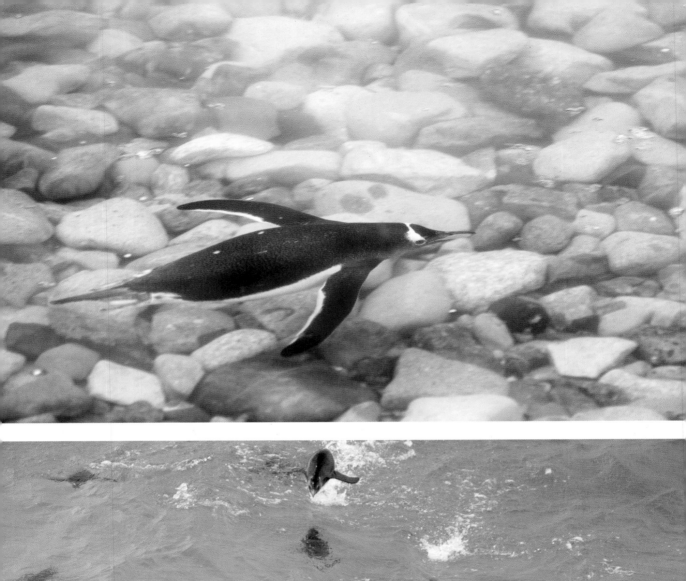

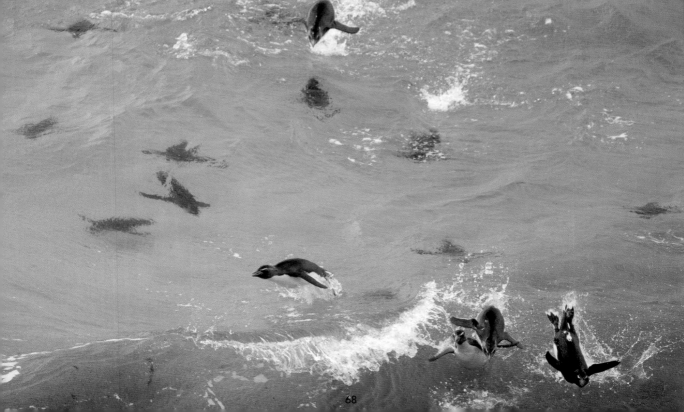

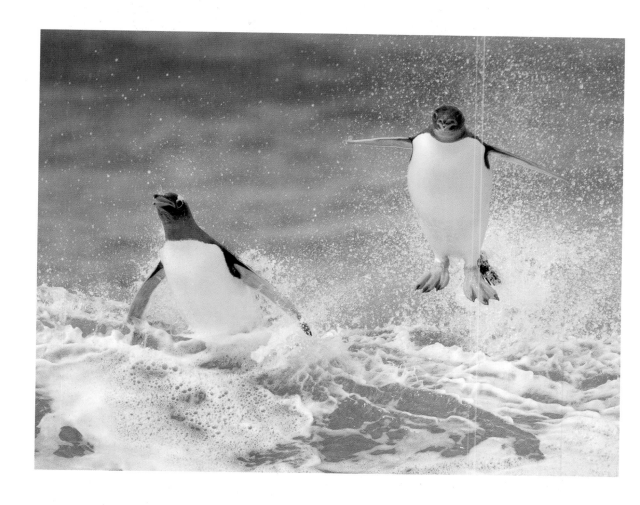

Opposite and above: Like many marine animals, penguins have rather vivid countershading. When diving deep for fish or krill their black backs blend with the darkness of the ocean depths, thus shielding them from the eyes of predatory seals, sharks and Orcas. Seen from below, the penguins' white bellies blend with the sky. If seen and chased by a predator, penguins like these Gentoo Penguins (*above and opposite above*) and Rockhopper Penguins (*opposite below*) will leap out of the sea repeatedly for greater speed when fleeing – an action known as 'porpoising'.

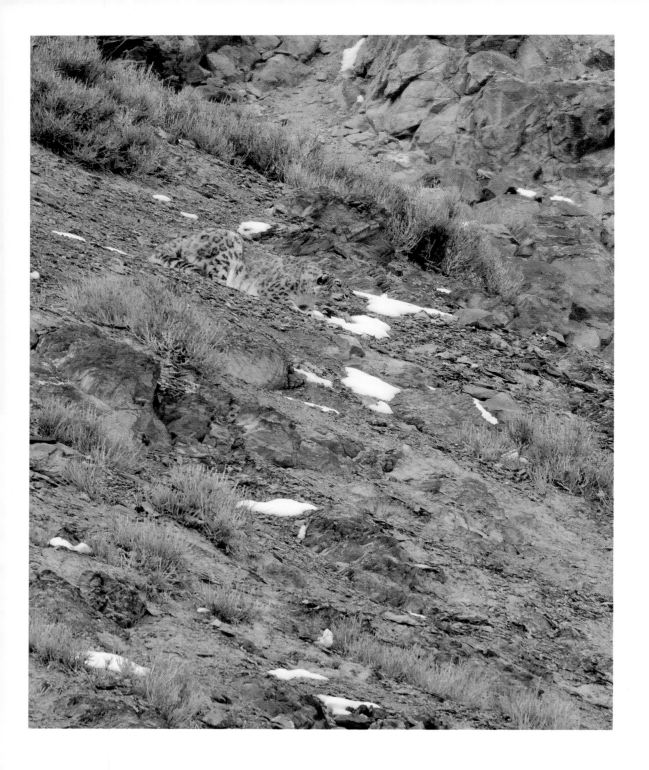

Above and opposite: Snow Leopards are incredibly cryptic. Locally, they are sometimes called 'the Grey Ghost' for their ability to vanish before your eyes. The Snow Leopard's white belly is clearly visible when it stands or sits, but when stalking the animal seems to disappear.

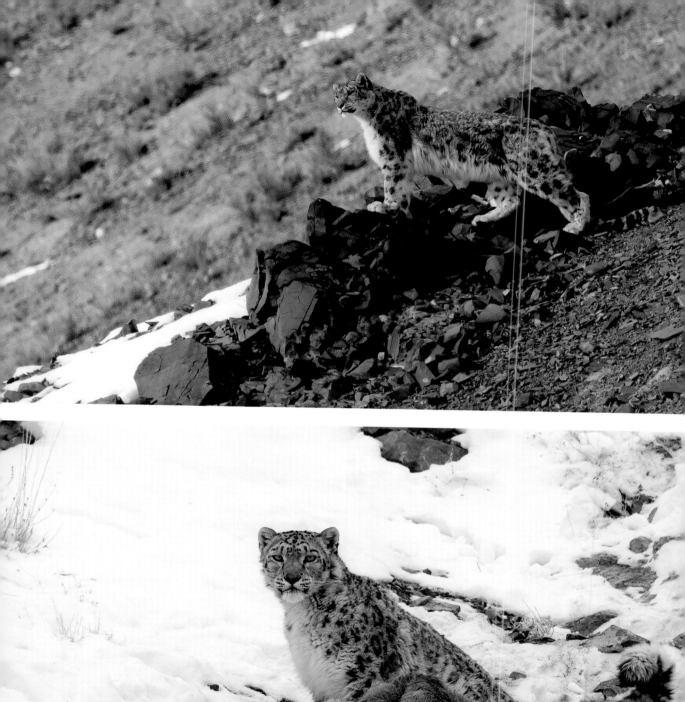
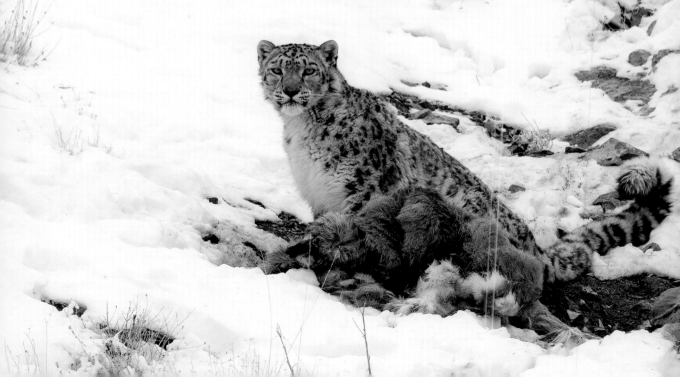

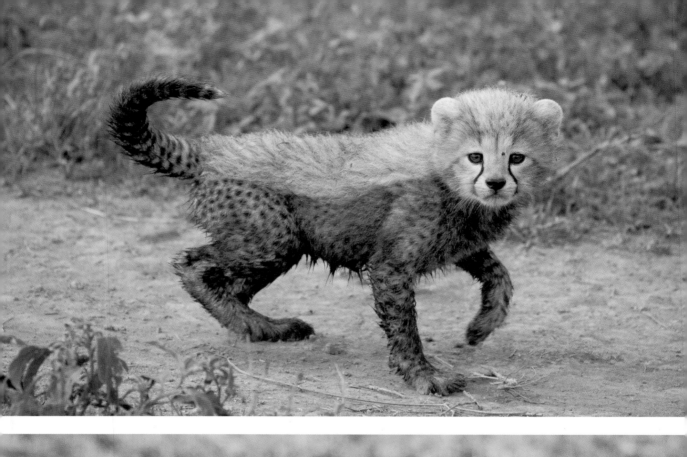

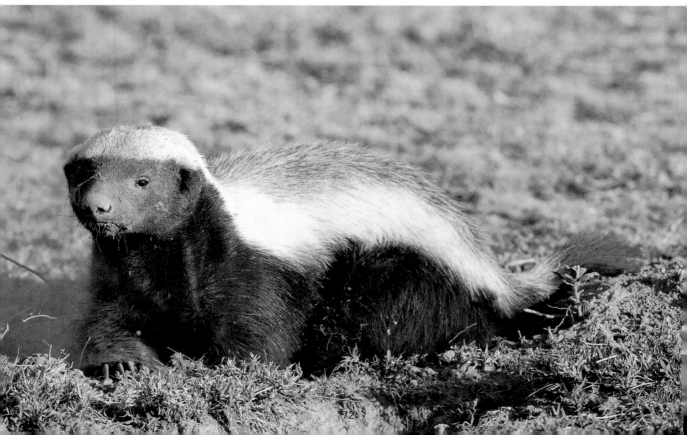

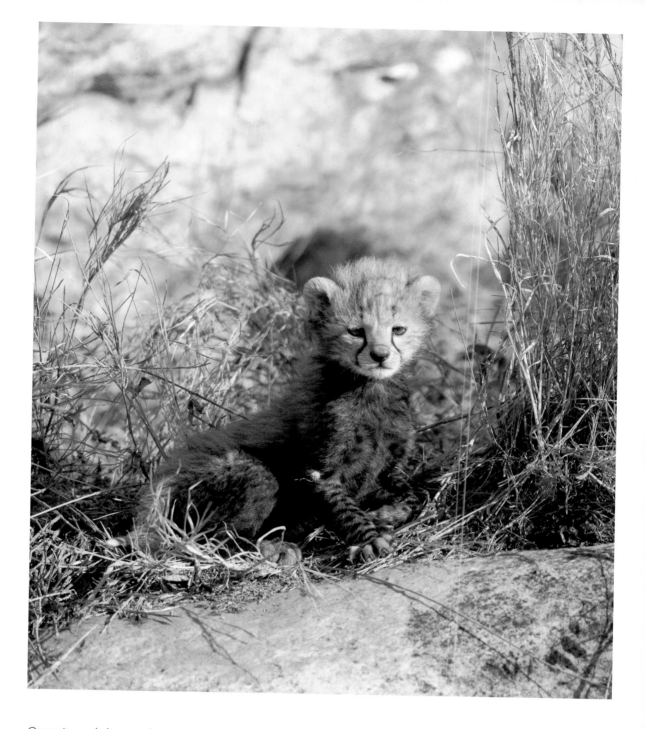

Opposite and above: In brush or long grasses a Cheetah cub's fur blends in well, but not when the cub is moving. To discourage predation when exposed, a young Cheetah's pattern mimics that of the very fierce and aggressive Honey Badger. In this way, the bicoloured appearance of a cub's fur functions both as classic countershading, but also a great example of mimicry. Considering the very high mortality rate of Cheetah cubs, this cat can use all the help it can get!

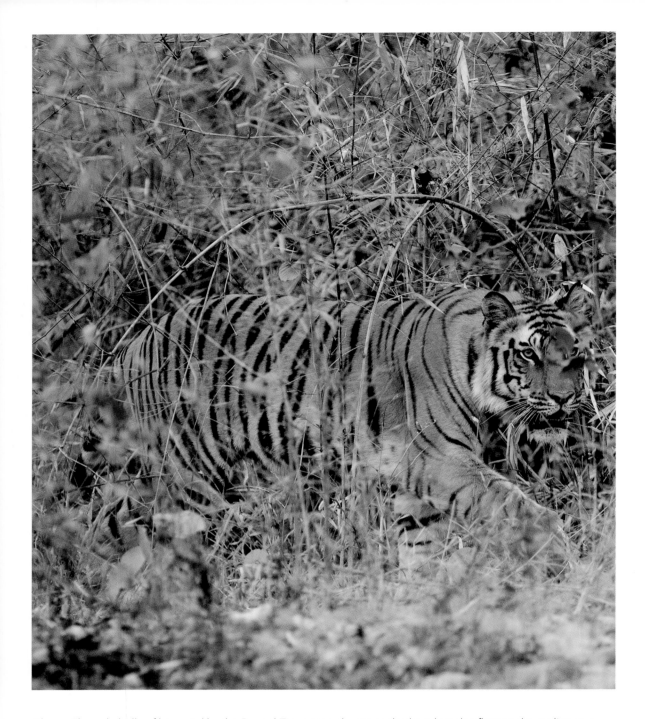

Above: The pale belly of big cats like the Bengal Tiger not only erases shadows but also flattens the outline to a two-dimensional shape. Seconds after this image was taken in central India's Bandhavgarh National Park this Tiger walked behind a small stand of bamboo – just a few stems in all – and vanished from sight.

Opposite: Until this Greater Kudu shook its ears this large antelope was unnoticed as it stood on the edge of a clearing.

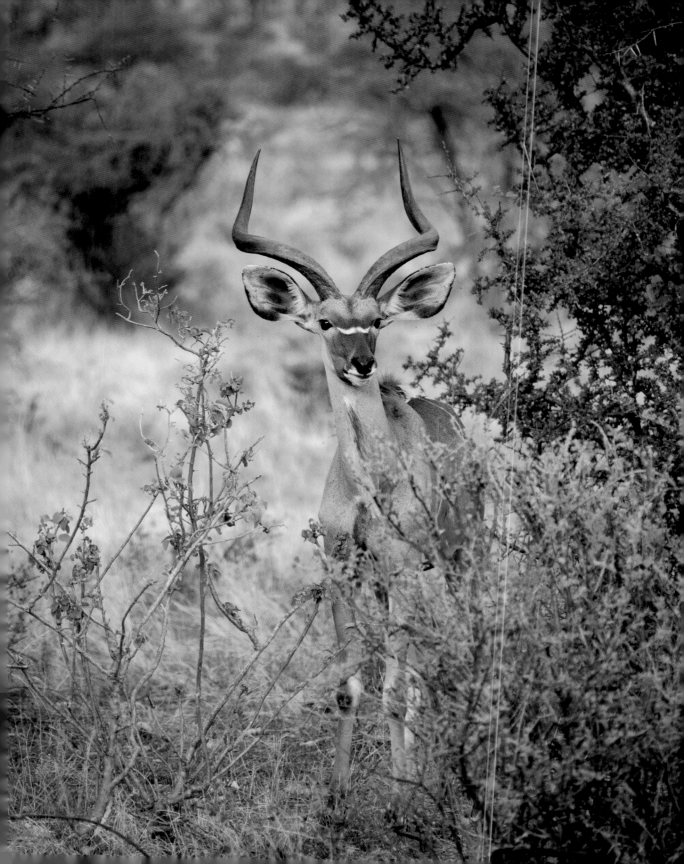

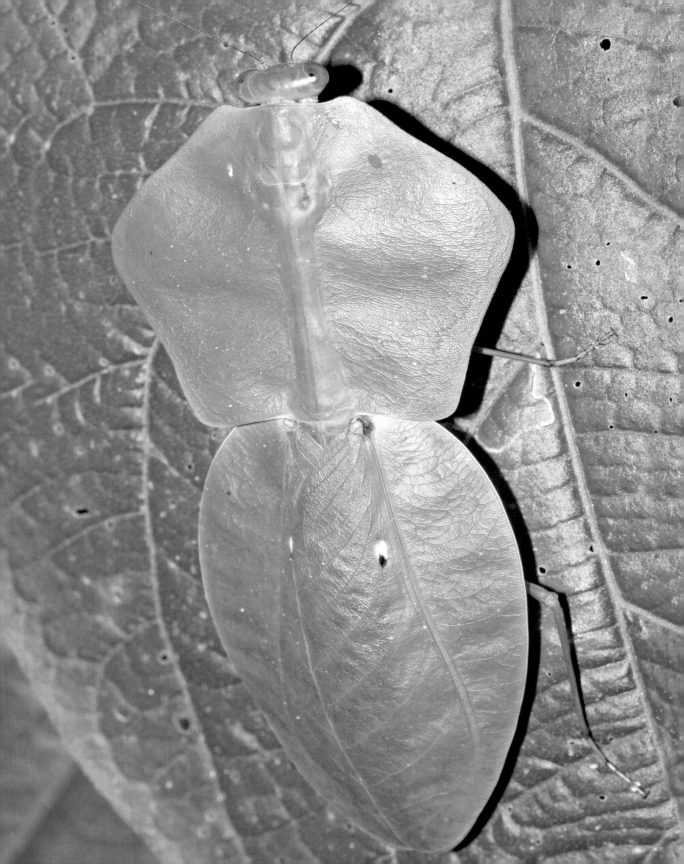

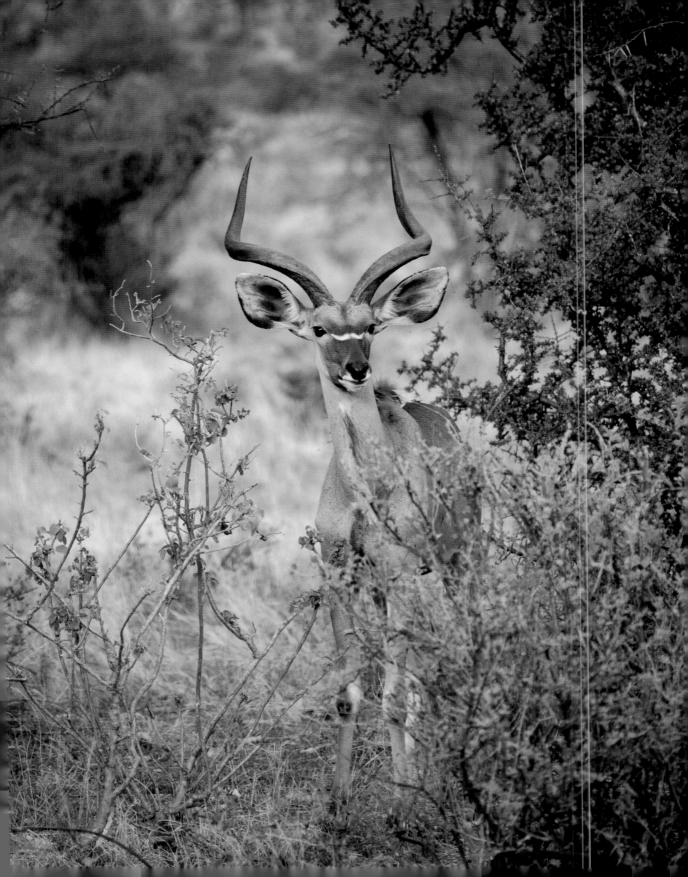

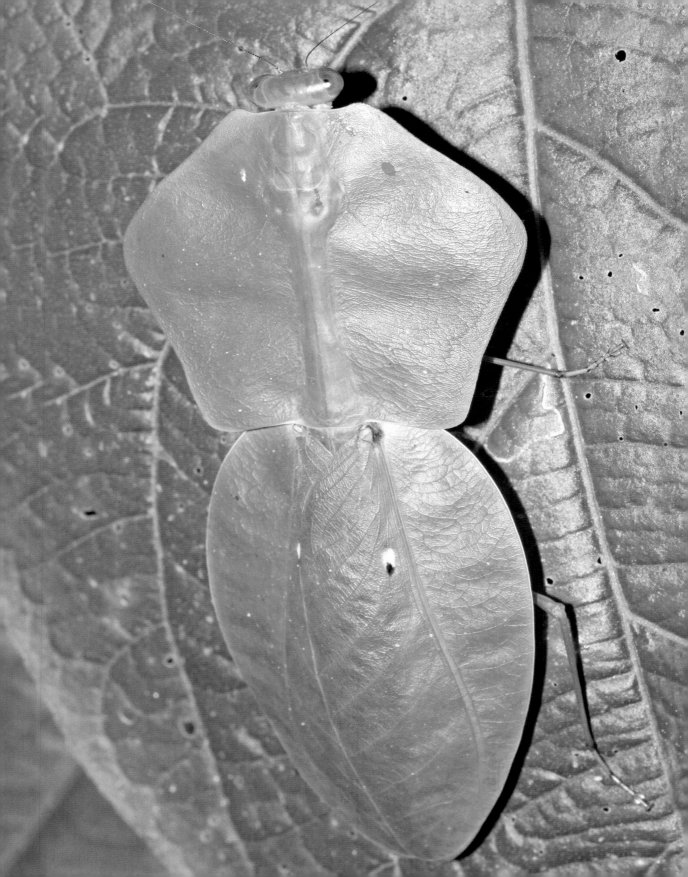

Shape & Colour

Animals can take on some very bizarre forms. The extraordinary shapes of various insects, fish and crustaceans can be so odd, so alien, that they could be from another planet. When isolated from its environs, either because the animal is removed from its habitat or because a photograph isolates the subject, shapes of these animals might seem bizarre. The purpose of these odd shapes, of course, is to blend in and make the subject disappear. An animal that is not only coloured like its environment, but is also shaped that way as well can be the most difficult of all to detect. Perhaps the quintessential example of this is the octopus, whose fluid, eight-legged body can seemingly melt into the landscape as this cephalopod not only matches the colour of a rock, coral, or algae leaf, but also its basic shape.

Some species are aided in this by having skin flanges, spines or flaps that either reduce the animal's shadow, by pressing tightly against a rock or tree bark, or by having a strange shape that a predator, or prey, would not immediately recognize. Geckos are perhaps the best example of the former, as some species of these lizards have loose flaps of skin that lay flat upon tree bark when the lizard rests, and in doing so the lizard seemingly melts into invisibility.

Basilisk lizards lack the flaps of skin that merge the body into a tree trunk or limb, but males of this family have a different tactic. They have prominent dorsal fins or sails that are reminiscent of the great sails of the prehistoric Dimetrodon, a mammal-like reptile often mistakenly called a type of dinosaur. The basilisk is spectacularly outfitted with a head crest, a longer sail that runs the length of its body, and another on the first third of its tail. While the crests of this lizard may perform other functions, these projections certainly break up the typical lizard outline and the animal blends in well with the riverside vegetation where it basks. Basilisk lizards have one other unique adaptation worth noting, although not related to camouflage. When threatened, basilisks literally run on water, sprinting ten yards or more before sinking beneath the surface and swimming, underwater, to safety. Not surprisingly, basilisks are locally known as 'Jesus Christ lizards', or 'Jesus lizards', due to this unique habit.

Invertebrates carry this alteration of body shape to the extreme. Many insects, especially in the tropics, resemble dead leaves or twigs. Some resemble the droppings of a bird or lizard, in both their shape and colour. Some resemble flowers, and when resting on the appropriate plant one is hard pressed to tell the two apart. Marine and aquatic invertebrates, and some terrestrial species, attach bits of material to their shells or bodies, actively camouflaging themselves with the material around them. Some of these, especially if they already mimic their habitat by their shape, are among the most difficult animals to spot.

Opposite: A whole host of different insects camouflage themselves as live or dead leaves. This image shows a hooded or shield mantis.

Instead of decorating themselves, some species of moths and the larvae of aquatic insects spin a type of cocoon that they attach plant material or small stones to, creating an extremely effective shelter. Bagworms, the larvae of a type of moth, may infest ornamental conifer trees in numbers, but because the bag is comprised of pine needles the pest often goes unnoticed until enough damage is done to the tree to require a closer look. Then, the innocuous bunch of needles turns out to be something quite different!

While mammals have retained, for the most part, a traditional shape, some birds have employed posture, pattern and, to a lesser extent, shape for camouflage. Many species of owl, for example, will perch in a quite erect position, seeming to stretch out to their full height, in an attempt to resemble a tree trunk. Owls possessing ear tufts will erect these feathers as well, thus heightening the effect. Some of the best practitioners at this type of subterfuge are the potoos and frogmouths. These birds are in the same order as the well-camouflaged nightjars and although the two groups, potoos and frogmouths, are quite distinct otherwise, they have evolved virtually the same form of camouflage. Their colour and pattern resemble a tree's bark and their posture – motionless, with the head pointed skyward – is virtually identical.

I can attest to the effectiveness of a potoo's camouflage. On more than one occasion as I photographed a roosting potoo in Brazil's Pantanal I was momentarily confused when I lost sight of the bird. Once, I was puzzled when a broken tree limb apparently blocked my view of the potoo I was photographing after I shifted about 90° for a different angle. It took me a few seconds to realize that this obstruction wasn't a limb at all; I was simply looking at the potoo!

Right: Members of the octopus family are adept at changing shape to blend in with their surroundings, or even mimic other marine creatures.

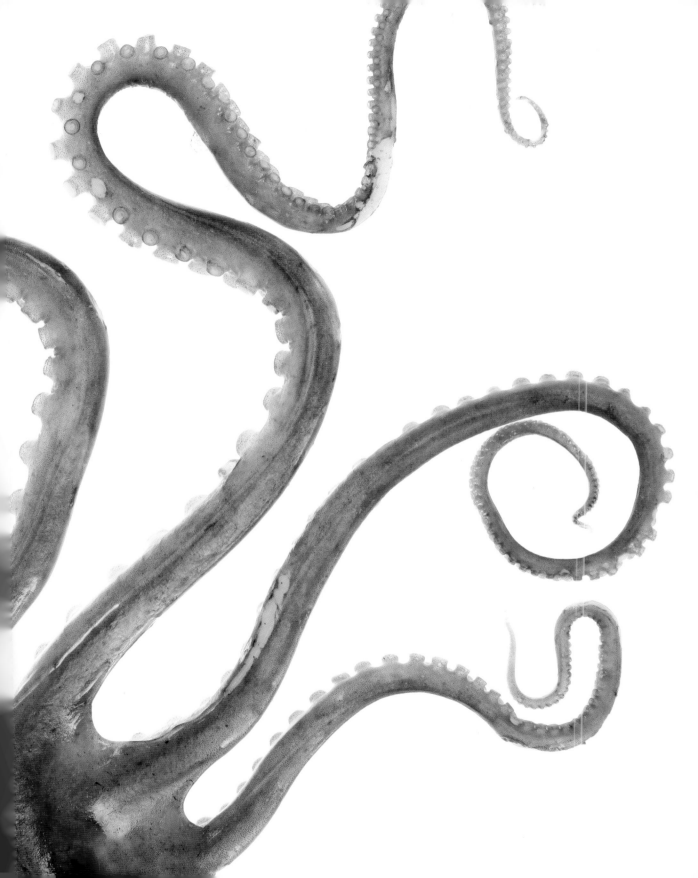

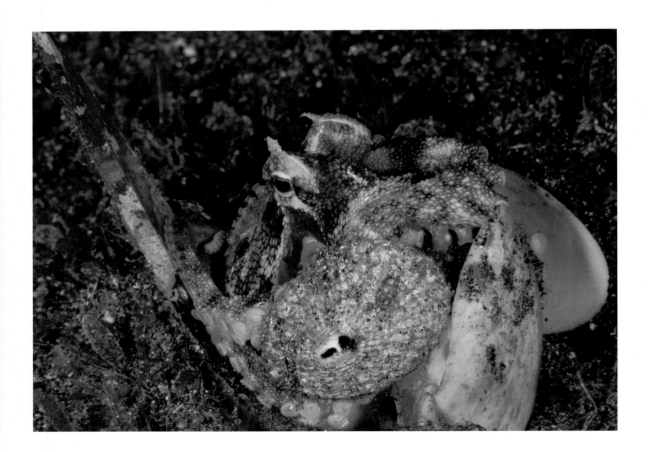

Above and opposite: One of the true masters of camouflage is the octopus. It can not only change colour, and do so almost instantly, but can change its shape and mould its body to mimic many features of its habitat. When disturbed, it has still another trick, ejecting a cloud of ink that distracts a predator while the octopus escapes.

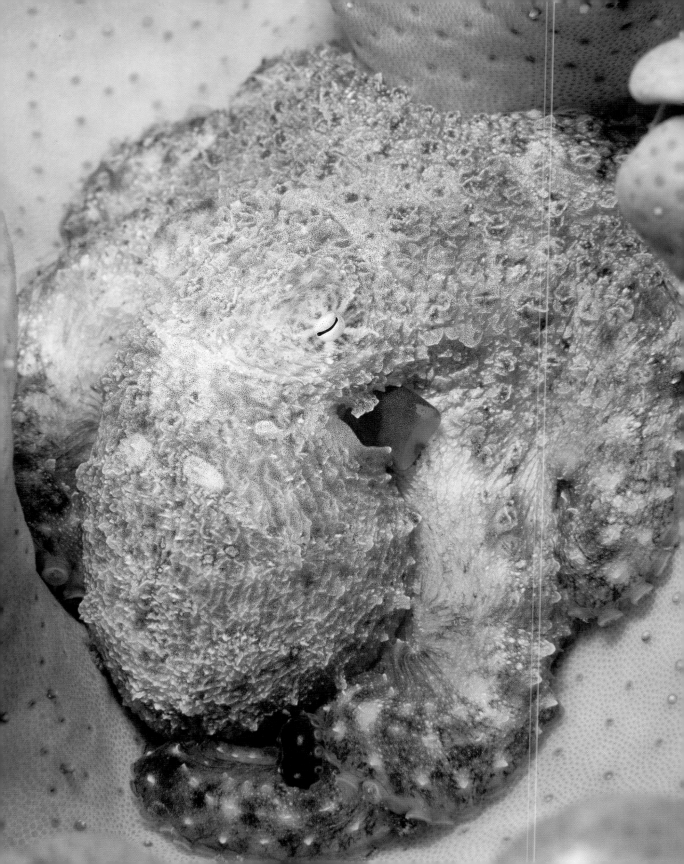

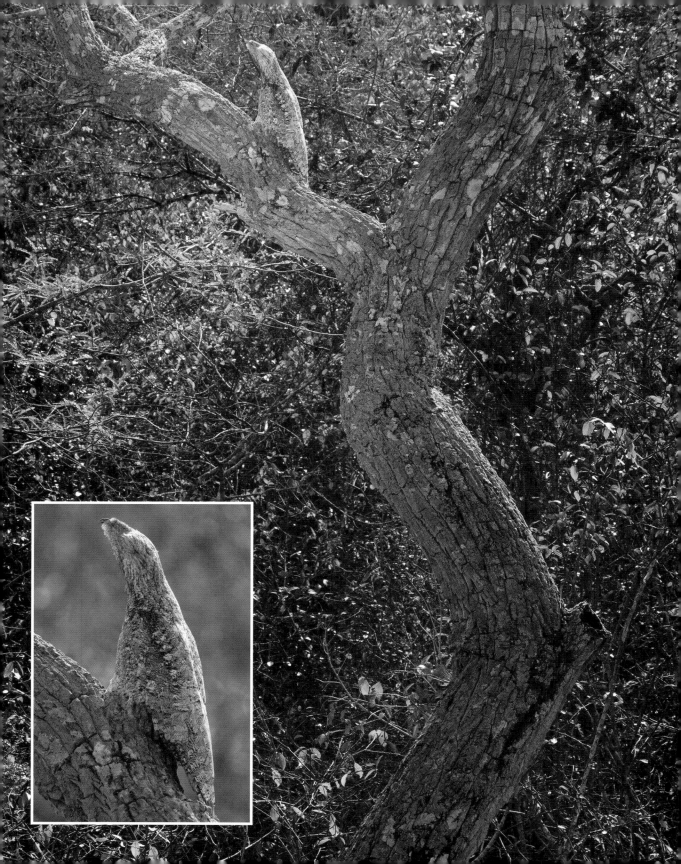

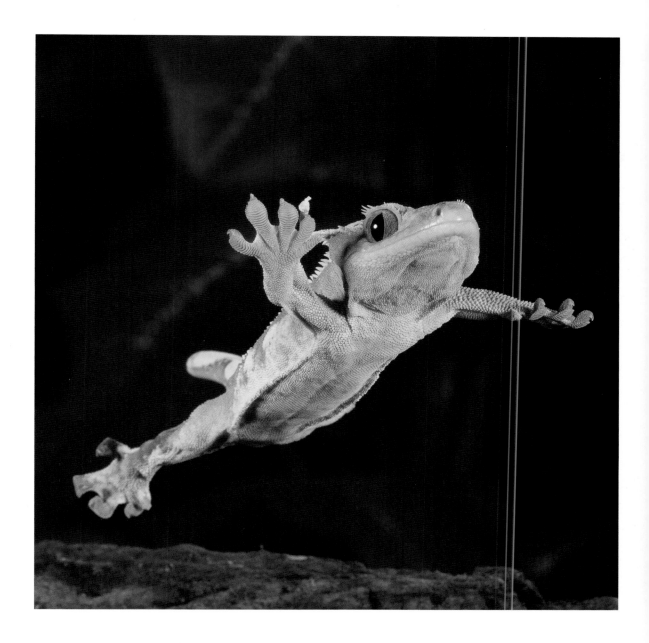

Above: Although well camouflaged, geckos are surprisingly agile and are capable of leaping twice their body length when lunging at an insect or darting away from a predator.

Opposite: The colour, pattern and posture of a resting Great Potoo makes it virtually indistinguishable from the tree limb where it spends the day. Relaxed, the potoo sits with its eyes open and its head held in a typical bird's pose, but when danger threatens the potoo raises its bill skyward, closes its eyes, and freezes, remaining motionless until the danger passes.

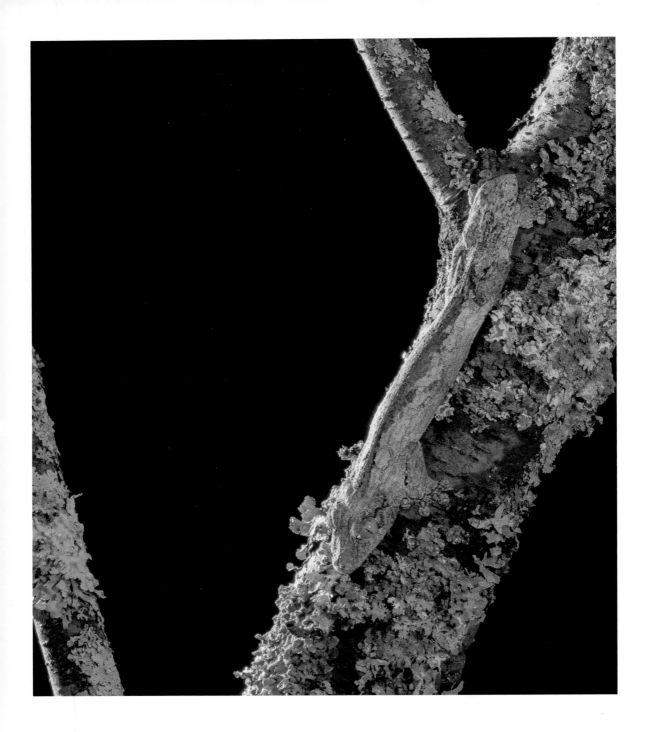

Above and opposite: These geckos all belong to the genus *Uroplatus* – also known as the leaf-tailed geckos – and all have flaps of skin that lay flat against tree bark, eliminating any shadow while seemingly merging with the bark itself. All have skin that matches the trees and vines which they use as shelters during the day.

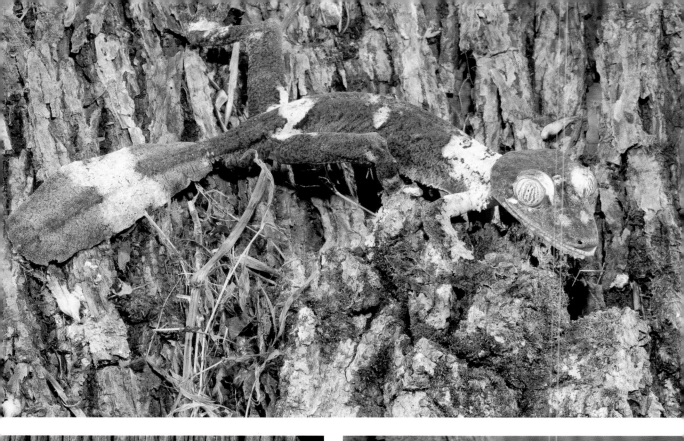

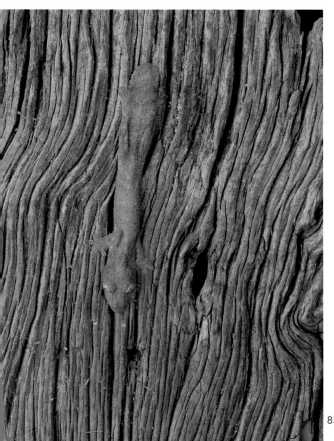

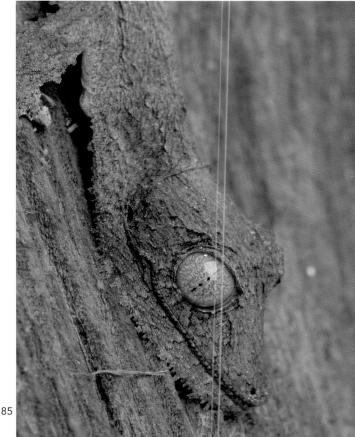

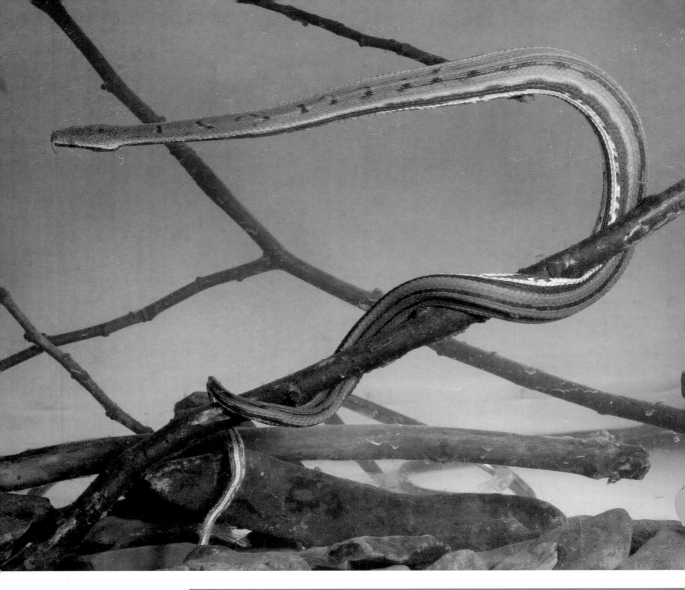

Above and right: The Tentacle Snake floats motionless among reeds and branches in freshwater ponds and streams. Stripes break up its outline, and two tentacles on either side of its snout act as lures for the small fish this aquatic snake eats.

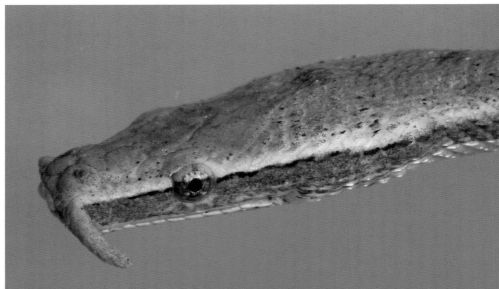

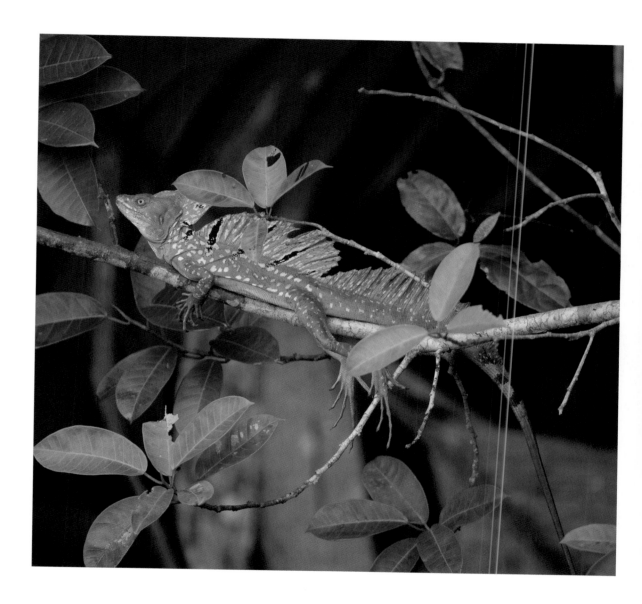

Above: The crests and sails on the basilisk disguise the typical lizard profile as it rests on a limb above a sluggish jungle stream. Spots on its flanks and bands on its crests and tail further complete its camouflage.

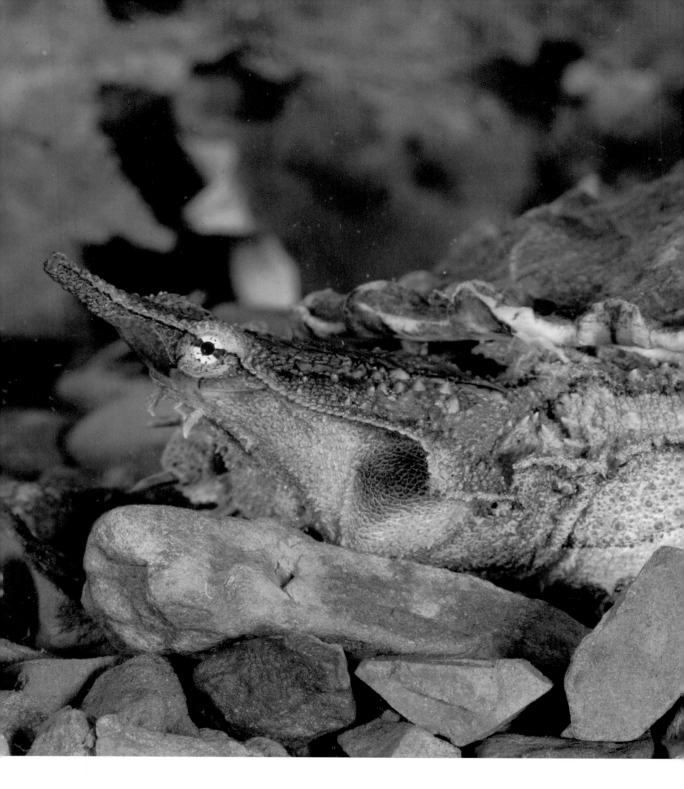

Above: In freshwater streams in Central America Mata-mata Turtles lie quietly among leaves and detritus where they wait for fish which they engulf with an explosive gulp, sucking in water and prey in a lightning-fast move.

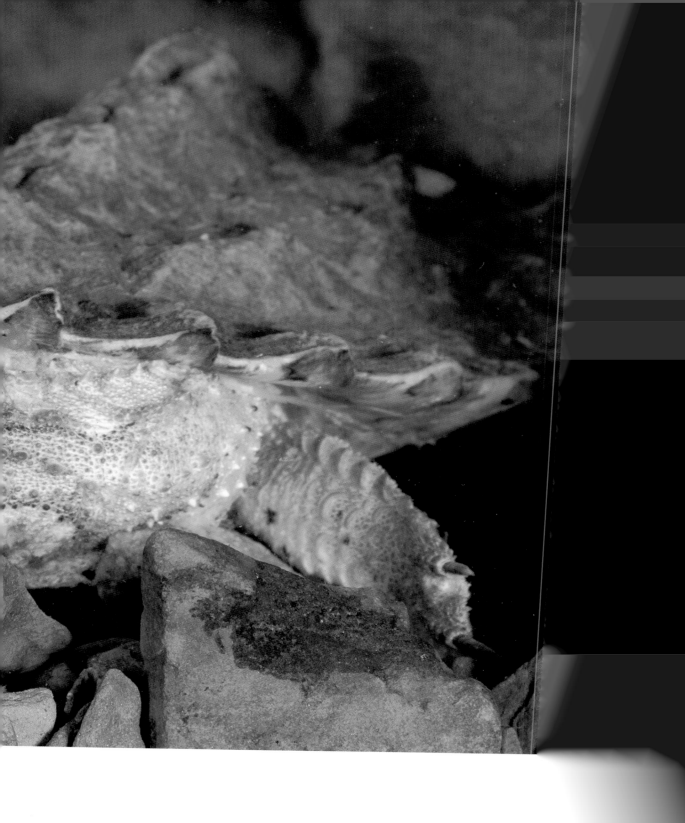

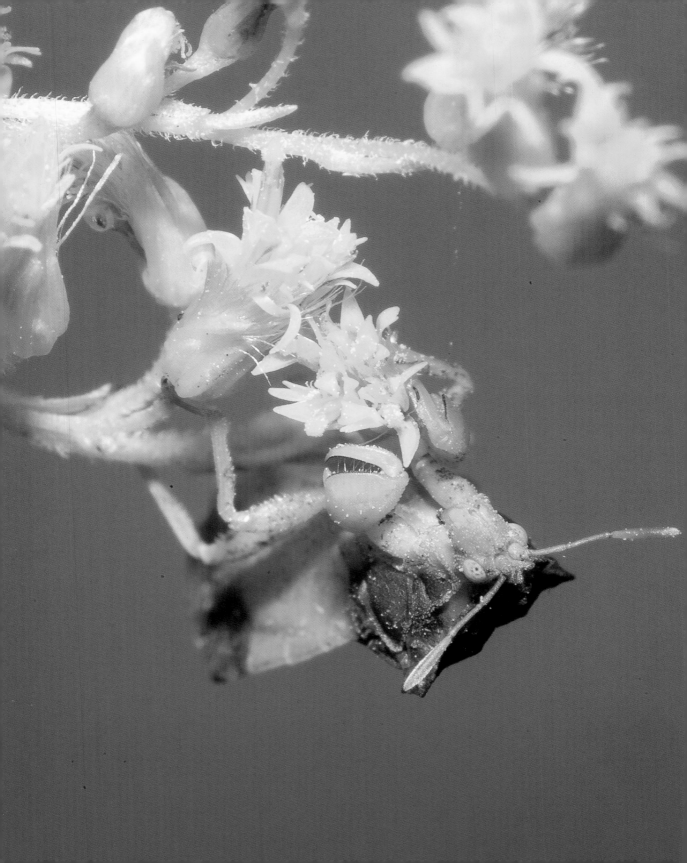

Opposite and above: The ambush bug is a common predator that sits quietly in or near flower clusters, where it waits for pollinating insects. Ambush bugs have powerful forelegs akin to the mantids and, like all true bugs, a sharp proboscis which they use for piercing prey.

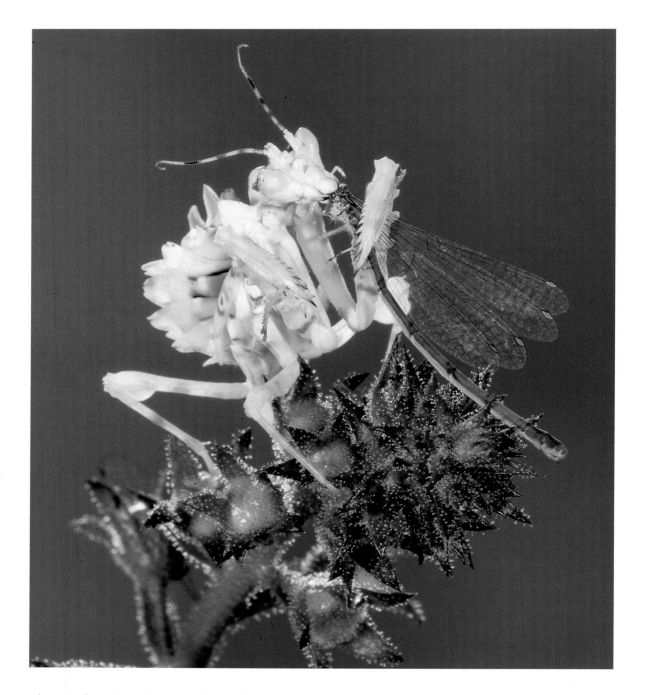

Above: At first glance, this Spiny Flower Mantis resembles a flower despite the fact that it is perching on a still unopened flower bud. In a florescence the mantid becomes invisible, as its colour and pattern mimic the surrounding flowers perfectly.

Opposite: Resting upside-down, this tropical leaf-mimic mantis is very easy to miss. Its camouflage is enhanced by the ragged, ripped appearance of its legs and abdomen, here arched backwards over its head, that resemble damaged or decayed leaves.

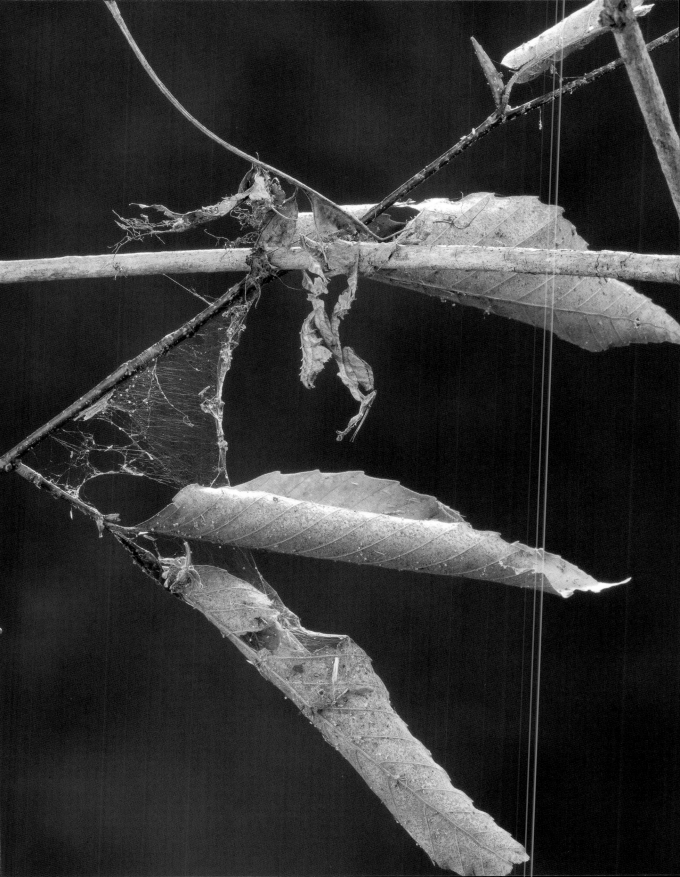

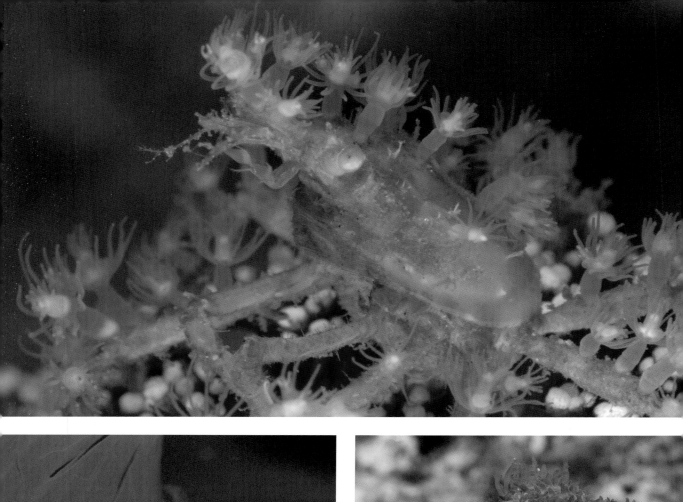

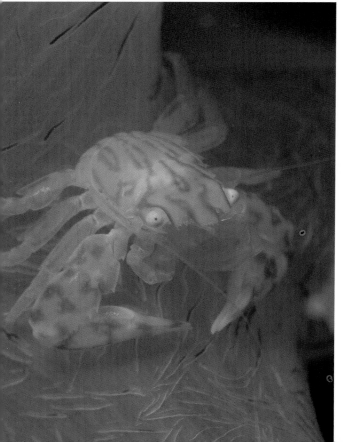

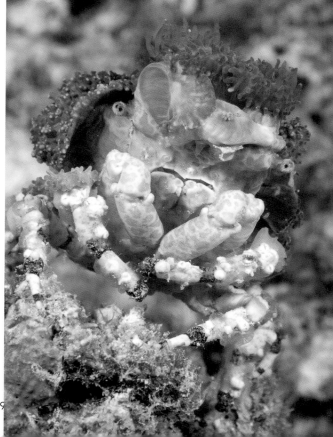

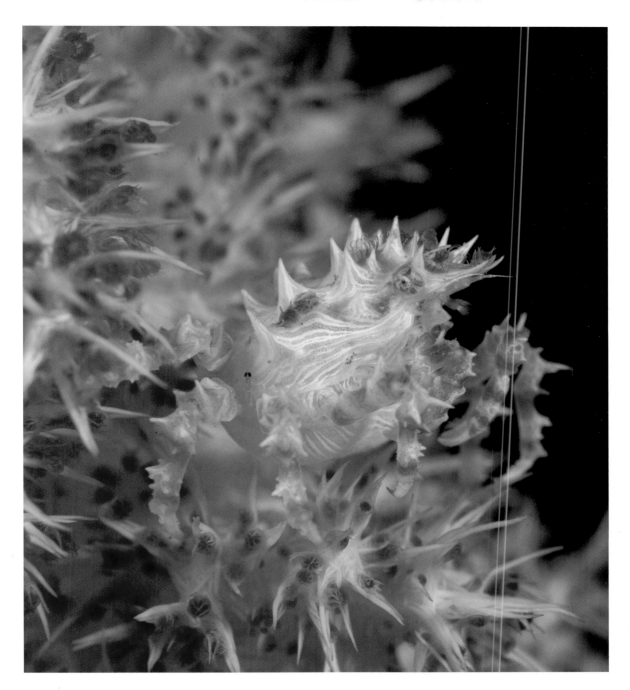

Opposite and above: While these small crabs perform vital roles as scavengers in their coral reef environments they also face predation from fish, octopus and other crustaceans. A variety of camouflage methods are employed to ensure that they remain unseen – the Indonesian Soft-bodied Crab (*above*) and Coral Porcelain Crab (*opposite below left*) have shells which provide good camouflage. Decorator crabs (*opposite above and below right*) not only use colour matching as camouflage, but they also enhance this subterfuge by adding bits of vegetation or anemones to their shell in order to complete the disguise. Since crabs grow by moulting their old shell, any ornaments they've added must be replaced on the new one.

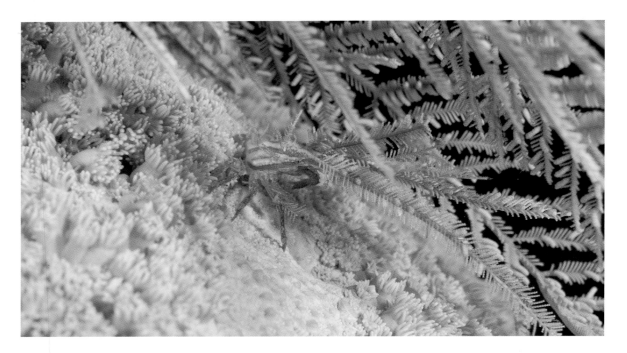

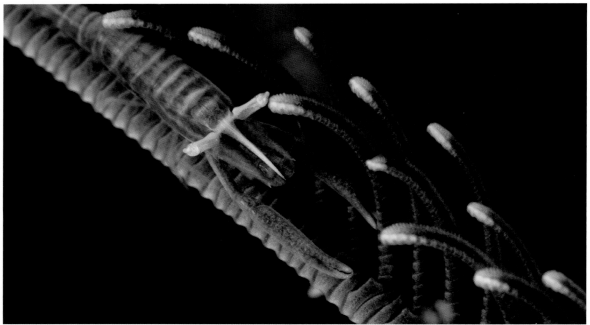

Above: Shrimps are among the marine world's champions in terms of camouflage, employing shapes and colours that mimic sea fans, corals and other features of their environment. Many enhance their deceit even further with translucent bodies, literally allowing a predator to 'see' right through them!

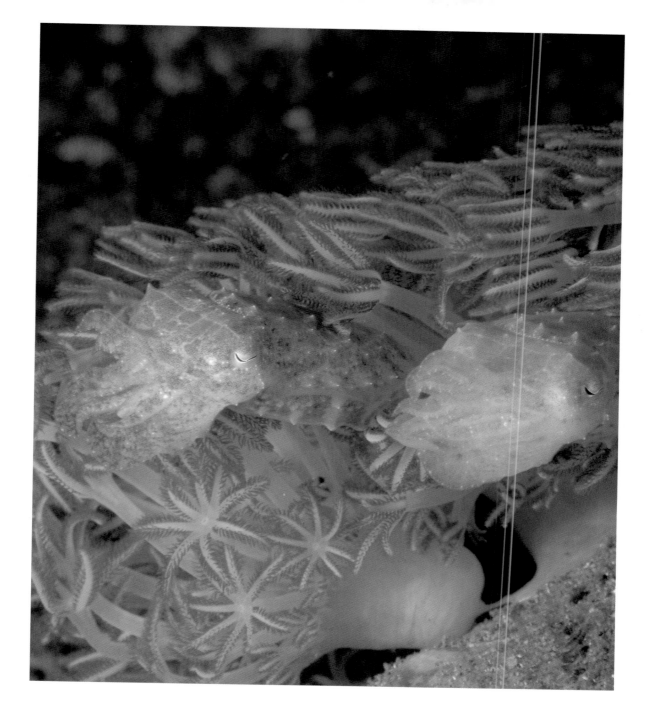

Above: Two crinoid cuttlefish, relatives of the squids, tuck into a cluster of octocorals, where they will spend the day.

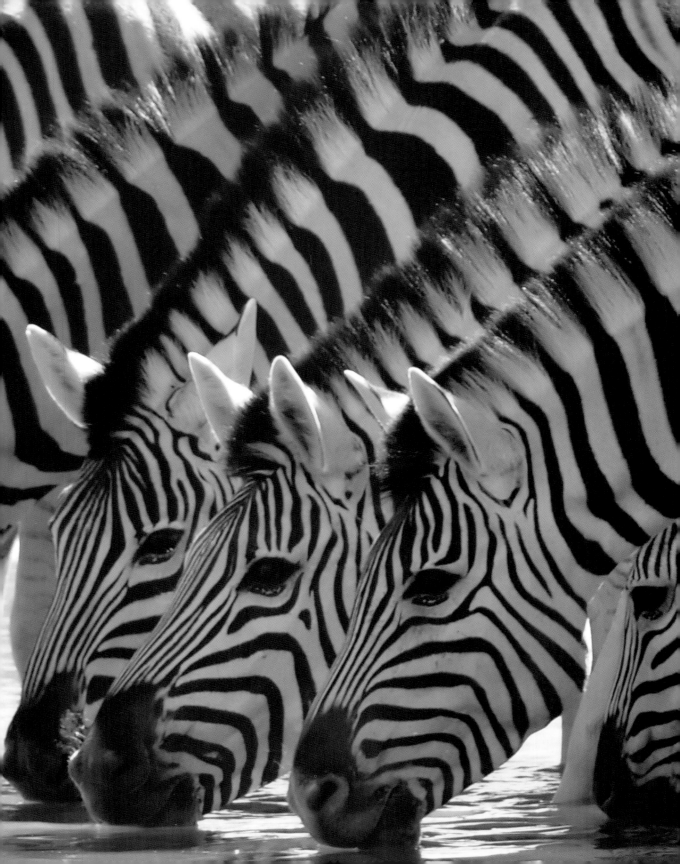

The Reasons for Certain Patterns

There is one type of pattern that to our eyes does not seem to provide any sort of camouflage at all, and that's the stripes of a zebra. Seeing a zebra in a zoo, or a wild one in the grasslands of East Africa on a sunny day, you would never think that the vivid black and white striping of this equine could be a form of camouflage. But it is.

While there are many theories as to why zebras are striped, and I'll discuss them soon enough, one suggestion is widely accepted. It is called motion dazzle, where bold patterns confuse a pursuing predator. Zebras are herd animals, and although individuals will often wander along on their own, and do so at their peril, most zebras travel in either family groups or, during migrations, in large gatherings of hundreds or even thousands. It is thought that a predator, like a Lion, may become disoriented or confused when charging in to a tightly bunched herd of boldly striped zebras. Bounding away in response, kicking up grass, dirt and dust, several zebras might seem to merge together as one, or confuse the big cat into suddenly switching from one targeted animal to another as the bold stripes, particularly on the rump, oscillate in distracting patterns.

I'm not so sure that I buy into this theory, for the Lions I've seen have patiently waited for a single, specific individual to come close enough, or to lag behind in a herd. Perhaps I haven't seen enough Lion hunts, and in the long run, in hundreds or thousands of hunts, where some undoubtedly did involve charges straight into a zebra herd, this motion dazzle effect may have contributed enough survival advantage to account for a zebra's stripes. So in this case, the camouflage isn't to blend in with the environment but to merge as one with other zebras, providing some safety in numbers as any single target might be lost, resulting in the entire herd escaping.

Another of the several theories advanced regarding why zebras have stripes involves camouflage and predator avoidance. Lions and hyenas, a zebra's two main predators, usually hunt at night, but may begin their hunting at dusk. From a distance, especially at twilight, a zebra's black and white pattern melds to a uniform grey, and thus merges with the increasingly monochromatic landscape as night descends. Wildebeest, another favorite prey item, only get darker in this same light, and so may capture a Lion's attention instead. Then perhaps the question arises, why didn't wildebeest evolve stripes too?

Motion dazzle certainly applies to the brightly coloured tropical fish that swim in schools. Bright stripes or vivid bars of yellow certainly are eye-catching, and in the frenetic dashes of a school fleeing a predator the conspicuous coloration, so seemingly inappropriate, might be extremely useful. Motion dazzle is exhibited by octopus, squid and cuttlefish too, as these cephalopods have the ability to change colour almost instantly and

Opposite: There are several theories as to exactly how a zebra's bold black and white stripes provide the animal with camouflage.

can flash one vividly conspicuous colour one moment and switch to an indistinct, camouflaged pattern the next as they dart to cover. The predator, still fixated on the bright glimpse of colour or the sudden appearance of an ink cloud (that may resemble the octopus or squid in shape) may miss its fleeing prey.

A startle effect is similar to motion dazzle and is a defensive strategy used by animals in virtually all groups. Many of these are well-camouflaged, inconspicuous creatures that suddenly flash a startling face or pair of eyes when threatened or disturbed. The Neotropical Sunbittern's normal camouflage is a mixture of disruptive coloration and colour matching, but when disturbed, especially when sitting at its nest, a Sunbittern will flash out its wings into a wide fan, revealing a set of dragon-like eyes that stare directly at the intruder. Similarly, the owl butterflies and some moths and other Lepidoptera have false eye-spots that quite resemble the eyes of an owl, especially when both wings fan out to reveal the wing's underside. At rest, only one eye-spot is visible on a side, but even then, if this cryptically coloured butterfly is noticed by a potential predator the intimidating-looking eye-spot might discourage a closer approach. Several species of the smaller owls and owlets employ a slightly different strategy to avoid being struck from behind by the small birds that mob these owls at every opportunity. On the back of their head these small owls have fake eye-spots, creating the illusion of eyes even larger than their real ones. From whatever direction a mobbing bird approaches the owl appears to be looking right back, and an attacking songbird might divert to strike from a different angle, and in doing so would be spotted by the true eyes.

Venomous reptiles, particularly coral and sea snakes and kraits, vividly advertise their lethal potential in bright colours, the classic examples of aposematism or warning coloration. Various insects do the same, with vivid colours and patterns warning predators of painful stings or bites or unpleasant tastes. Nearly all of these creatures also have mimics that closely match their dangerous models, like the Scarlet Kingsnake mimicking the venomous coral snakes, the Viceroy butterfly mimicking the foul-tasting Monarch butterfly, or harmless robber flies mimicking bumblebees and wasps.

However, while the bright colours like those of the kingsnakes attempt to deceive predators, when a kingsnake flees a surprising thing happens. As it rapidly crawls away the snake's bright colours blend together into a neutral, inconspicuous shade, and instead of drawing attention to the snake, the colours now blend in with the landscape. The Fire-bellied Toad, an attractively patterned small toad from Europe, does something quite different with its most prominent feature, its belly. The dorsal surface of this toad incorporates colour matching and disruptive coloration, but the toad also incorporates a startle effect when disturbed or flipped, as its belly is a vivid red and black – a visual clue as to the toad's unpleasant taste.

Extremely well camouflaged animals may display a highly visible lure to draw in prey. Several species of fish employ special fins or outgrowths to act as bait, and young pit vipers of several species, like the Copperhead and Fer-de-lance, do the same with a brightly coloured tail. Lying coiled in a pile of dead leaves, an otherwise inconspicuous Copperhead neonate (baby) will wiggle its vivid yellow tail whenever it spots a small frog or salamander, enticing the amphibian to grab this 'worm.' When the frog gets close the snake strikes and has a meal of its own. As these snakes grow larger this caudal luring is no longer necessary. The yellow tail fades to black as the adults switch their diet from small amphibians to rodents and other small mammals.

In contrast, the relatively tiny Peringuey's Adder of south-west Africa's Namib Desert feeds on lizards throughout its life and maintains a tail lure even as an adult. Living in one of the driest, most barren deserts in the world, this viper burrows into the sand to protect itself from overheating, exposing only its eyes and snout, and the tip of its tail, which it wiggles to attract the attention of small lizards.

Opposite: Eye-spots on the hindwings of a Common Blue Morpho butterfly may startle or deter potential predators.

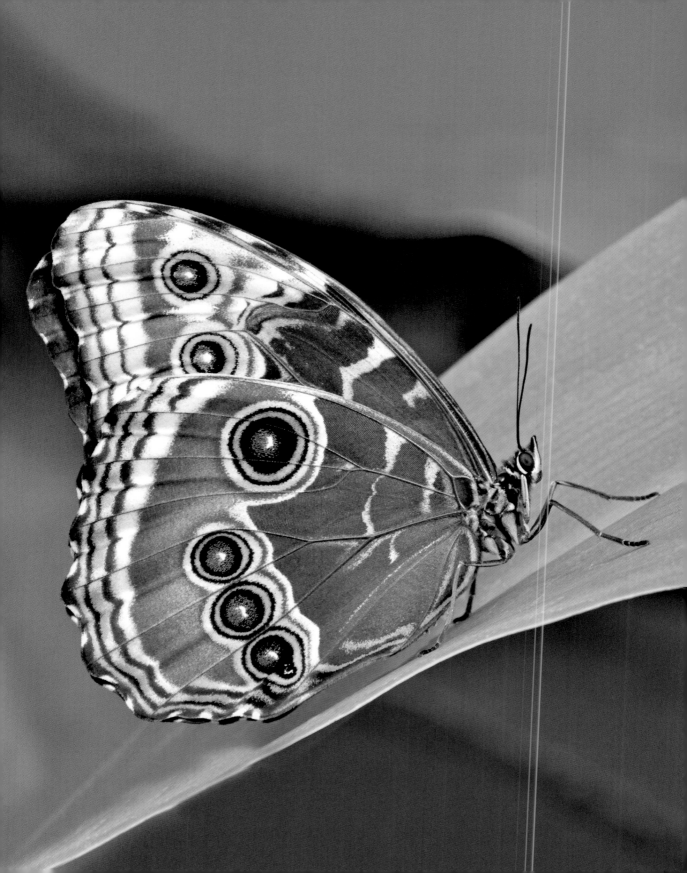

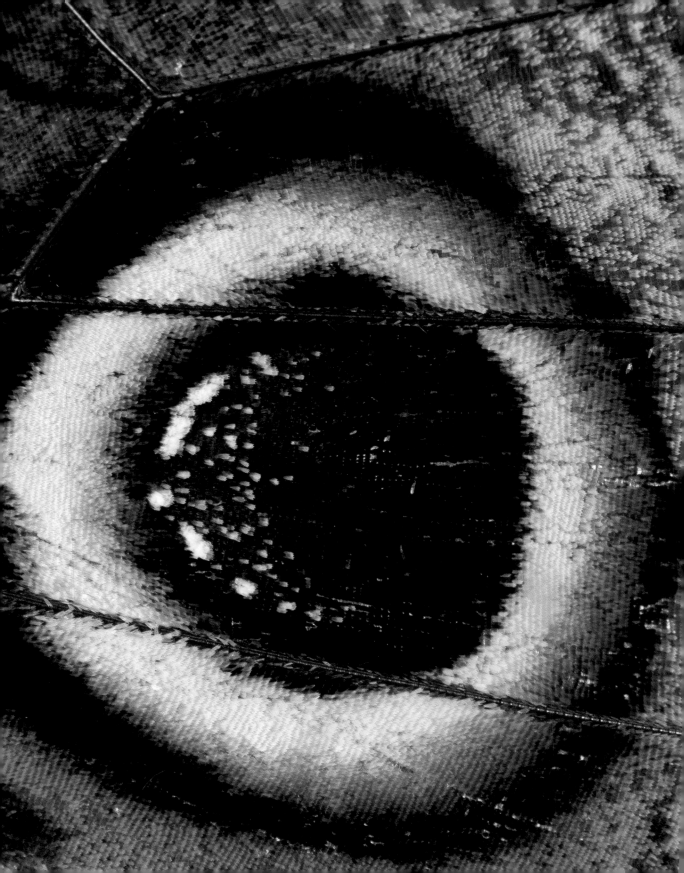

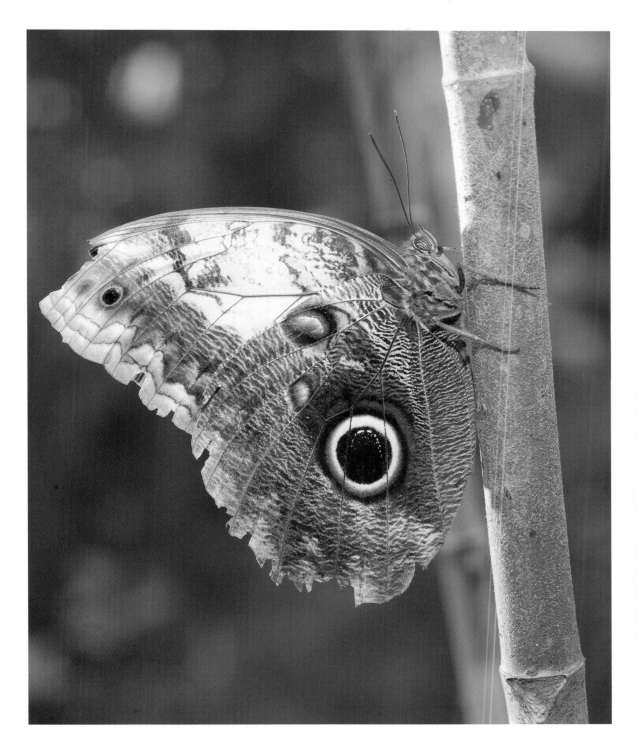

Opposite and above: While cryptically coloured, the vivid eye-spot of this owl butterfly may play two roles in furthering the butterfly's defence. If startled, the butterfly flashes its wings, revealing both eye-spots simultaneously, creating the illusion of an owl's face by doing so. At rest one eye-spot is always visible, seeming to peer out, and this too may deter a potential predator from coming closer.

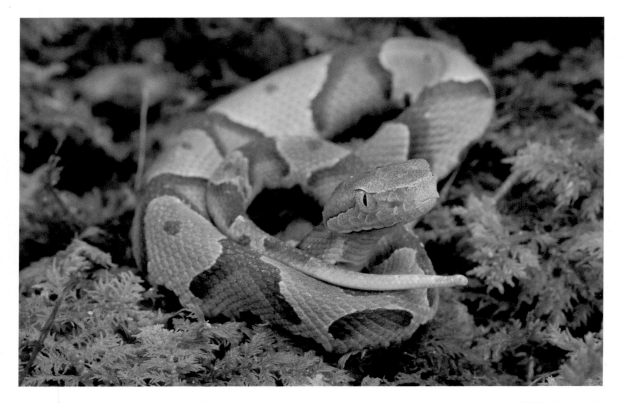

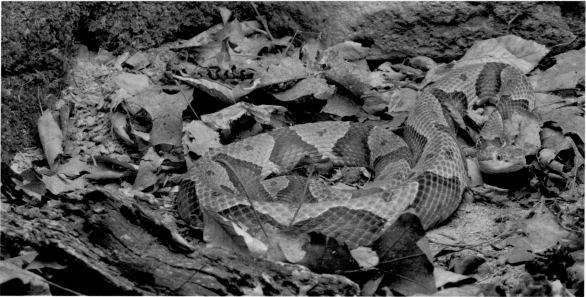

This and following spread: While both neonate and adult Copperheads (*top and above*) and Fer-de-lances (*overleaf and opposite*) are cryptically coloured, their diets change as the snakes grow larger. As juveniles, these pit vipers feed upon small frogs and salamanders which they lure close by wiggling a bright yellow tail that resembles a worm or caterpillar. As adults, these snakes feed on warm-blooded prey and the tail lure is no longer needed. At this time the tail-tip colour changes to a darker tone.

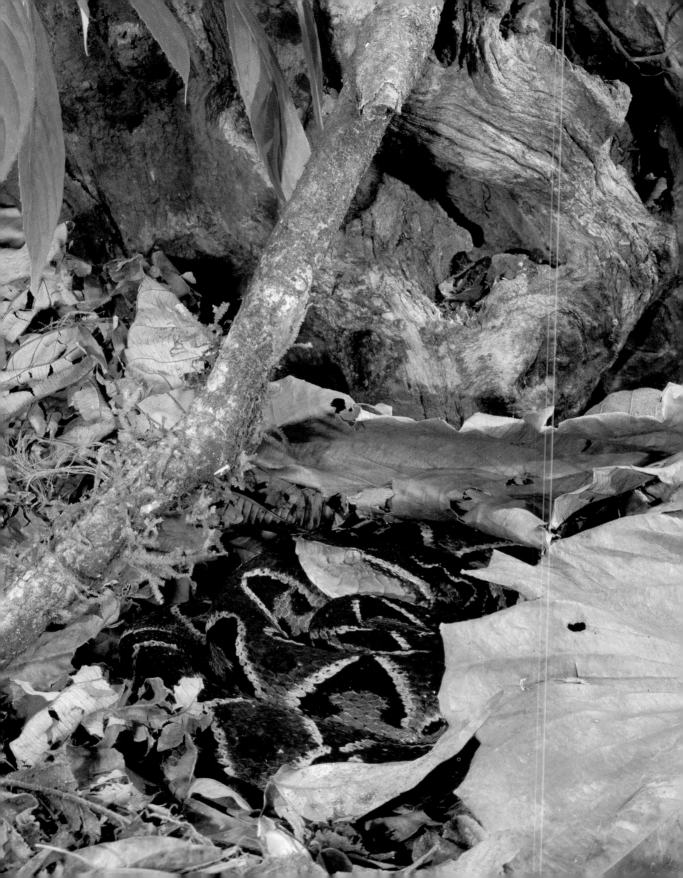

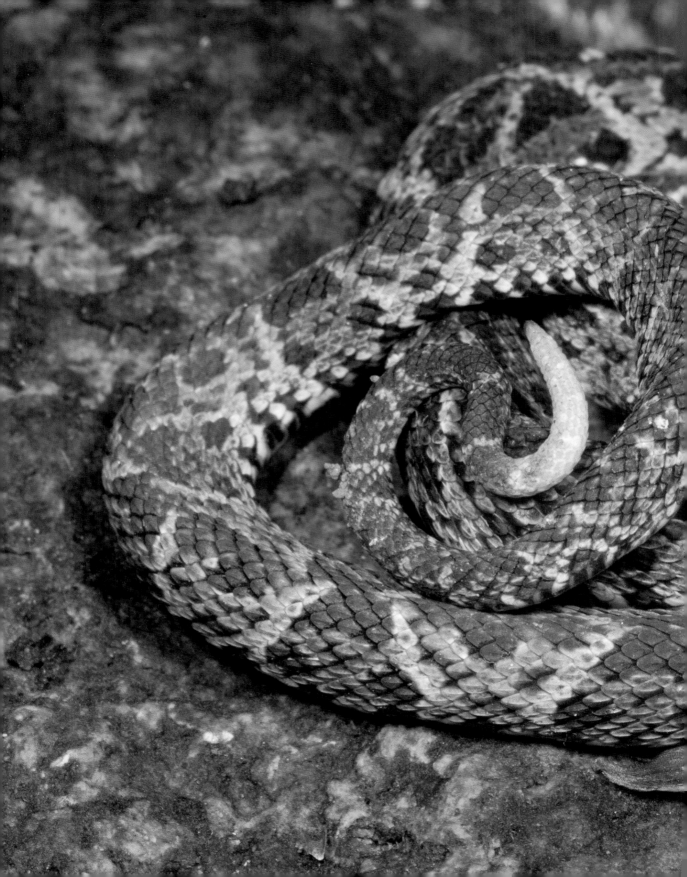

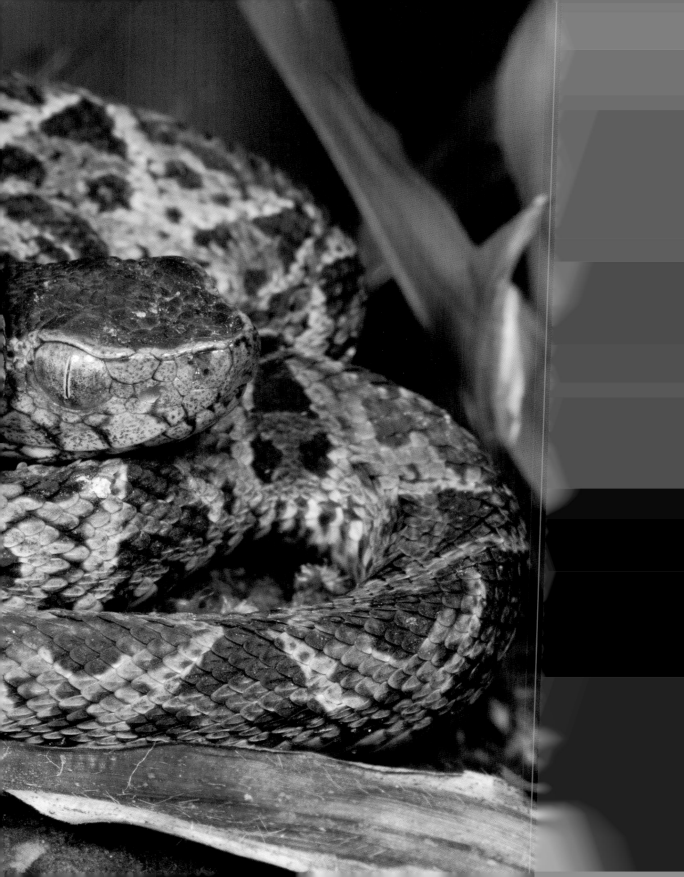

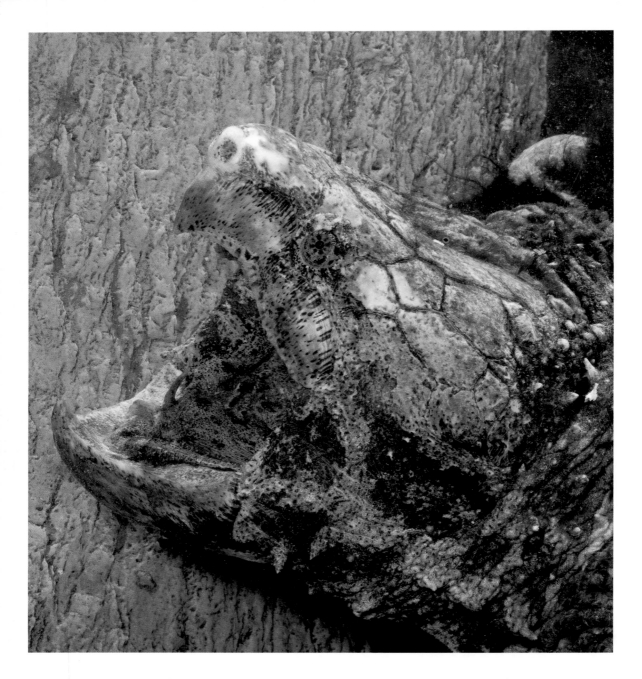

Above: The shell and skin of the Alligator Snapping Turtle of the south-central United States is frequently covered in a coat of algae, making this ambush predator nearly invisible. This huge aquatic turtle, which sometimes weighs over 75kg (165lb), is unique among North American turtles because of its use of a lure – a worm-like appendage on its tongue which it wags slowly to attract fish.

Opposite: The tiny Peringuey's Adder buries itself into sand to escape the heat of the desert sun, keeping only its snout and eyes exposed. These small snakes feed upon lizards, which they attract by using their tail as a lure, poking and wagging the appendage above the sand.

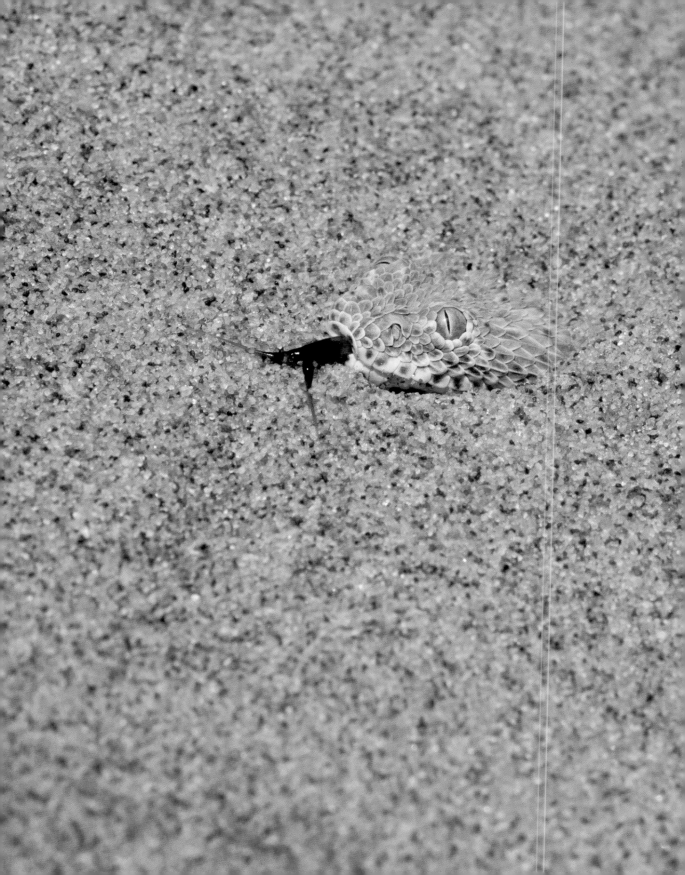

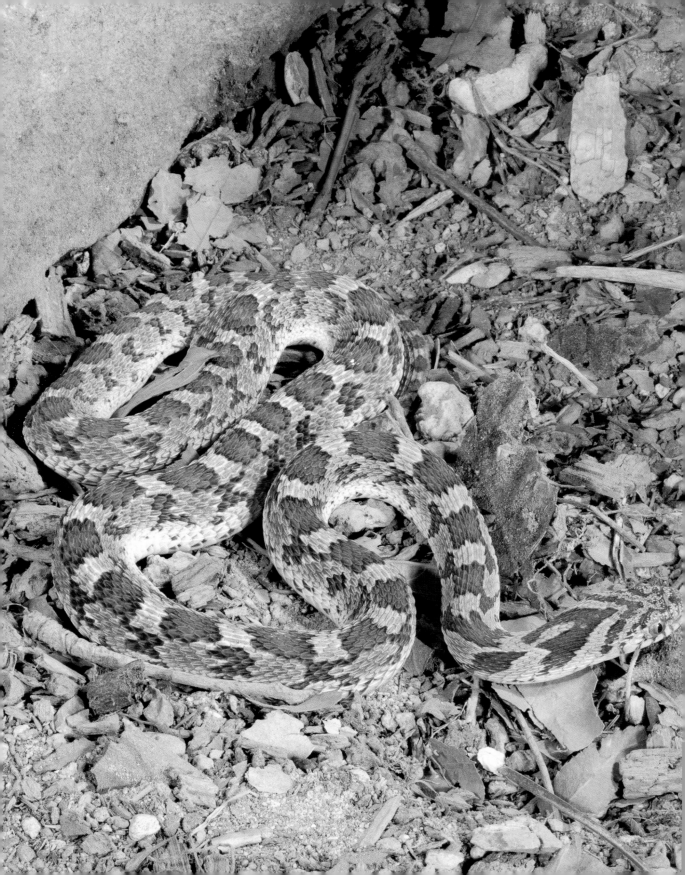

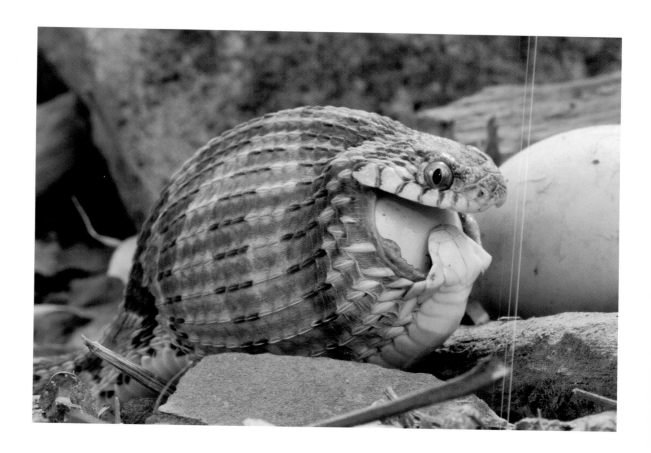

Opposite and above: The disruptive coloration pattern of this egg-eating snake shields it from detection and possible harm. If discovered, the snake risks injury or death as birds protecting their nests will gather in numbers to mob this predator, pecking and stomping at it. When mobbed, egg-eating snakes will freeze and play dead – a ruse that often defuses the aggression of protective birds.

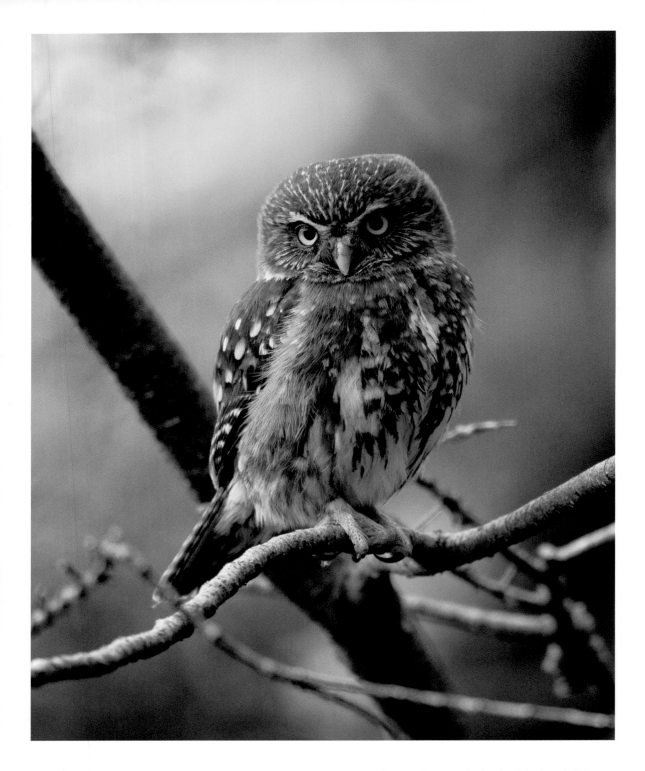

Above and opposite: Pygmy owls seem to have four eyes, two in the front and two in the back of the head. False eye-spots may prevent the owl from being struck from behind when mobbed by flocks of small birds. This is an Austral Pygmy Owl.

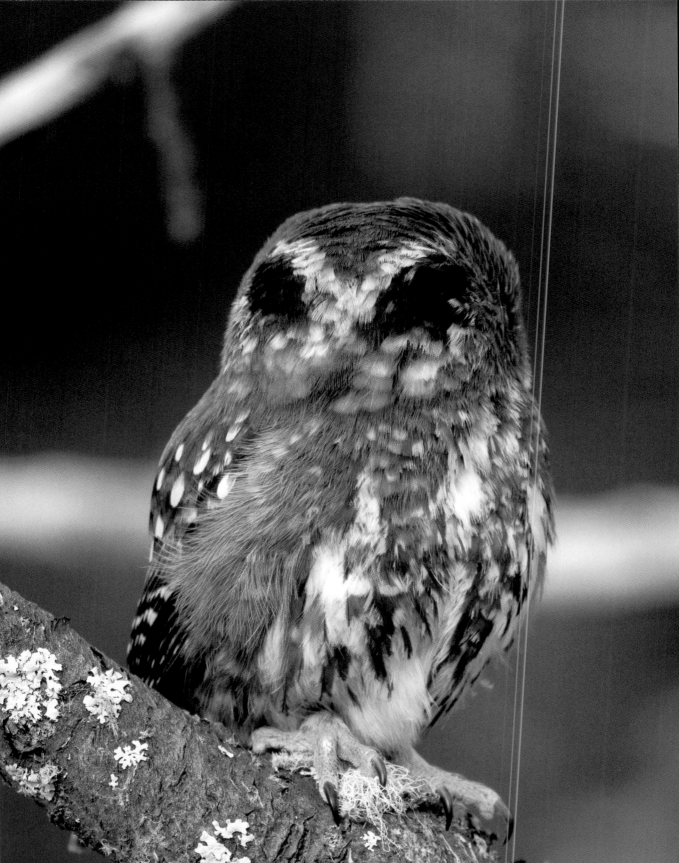

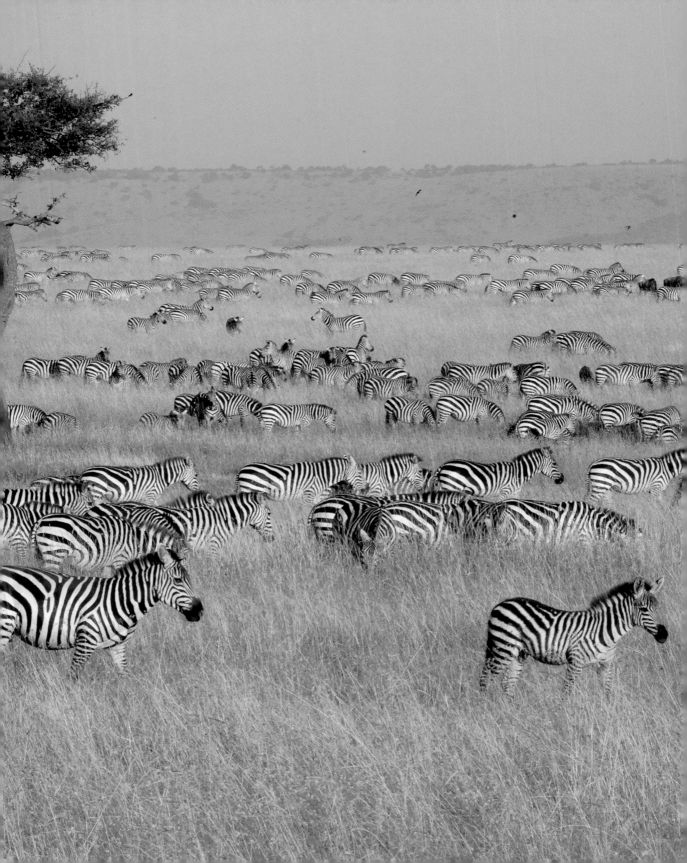

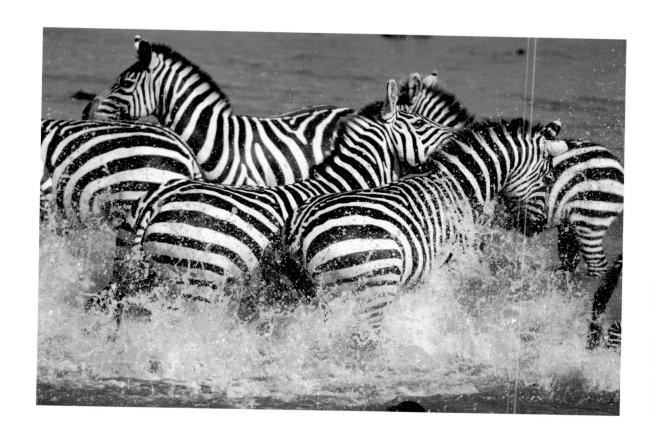

Opposite and above: There are many different theories attempting to explain why zebras have their stripes. At dusk, when seen from a distance, a Common Zebra's vivid pattern of black and white stripes merges to a uniform grey that fades into the landscape. When attacked, the bold stripes of one zebra helps it to merge with others in the herd, possibly confusing a pursuer and providing critical seconds that may make the difference between life or death.

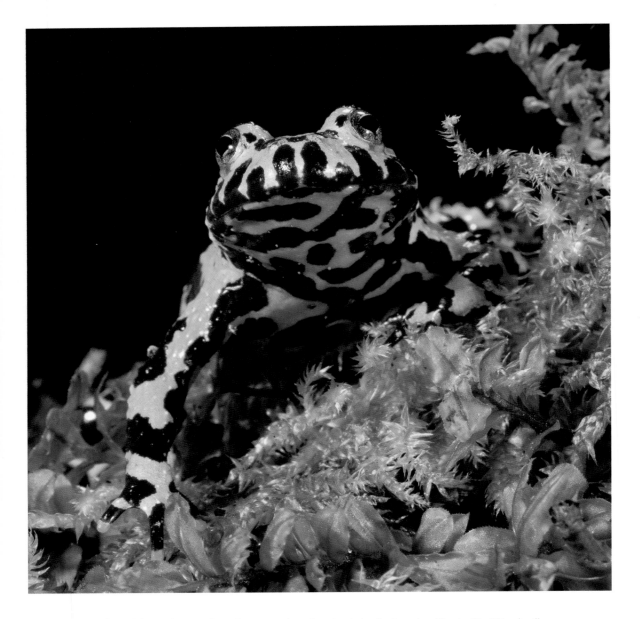

Above: Camouflaged from above, when threatened or disturbed the foul-tasting Fire-bellied Toad will rear up on its legs to display its red belly, warning predators away. This defence will not work on a predator that has never encountered this toad, and the unlucky amphibian might be killed. However, the experience will not be pleasant for the predator, and in subsequent encounters with this species the predator is likely to shy away. Bright colours are used by a variety of venomous species from every animal group to act as a warning device.

Opposite: This non-venomous Sonoran Mountain Kingsnake is certainly not exhibiting camouflage in this image, but when crawling rapidly the bright colours merge to form a neutral blur which blends in surprisingly well with the background. The vivid pattern may serve another function, however, as the colours mimic that of the venomous coral snakes. Oddly, however, the ranges of the two snakes do not overlap, as the kingsnake is found at much higher elevations than the desert-dwelling coral snakes.

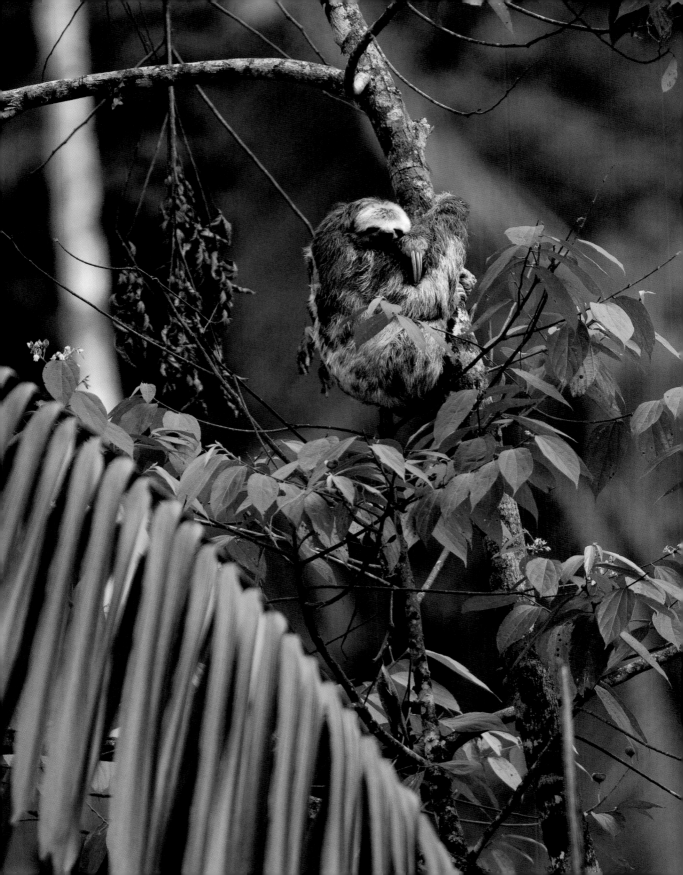

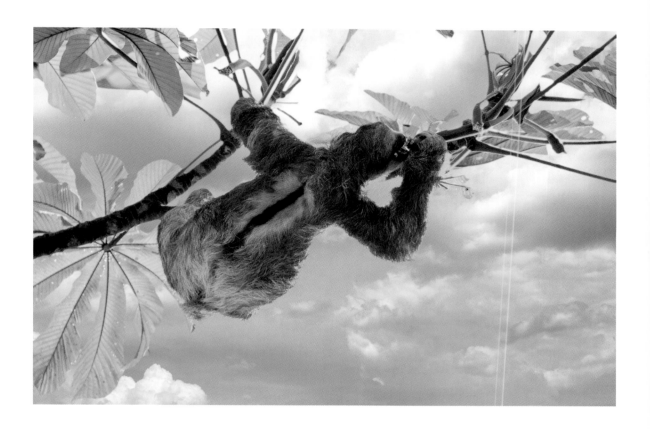

Opposite and above: As you might expect, Three-toed Sloths move slowly enough that any movement on their part might go unnoticed by a predator. They can be very difficult to spot in the jungle canopies of Central and South America as their unique fur coats harbour a growth of algae, giving the fur a greenish cast. At rest, in the crook of a tree, the sloth resembles a collection of leaves.

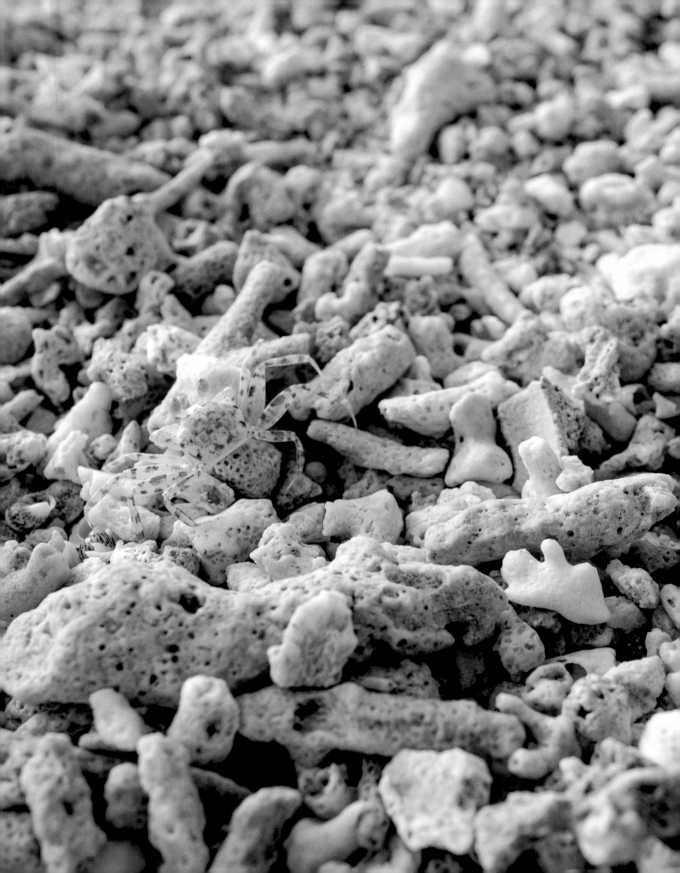

Hide & Seek

The preceding sections of this book have illustrated the various types of camouflage animals employ to remain hidden, either from the eyes of predators or of prey. Oft-times this camouflage performed a dual role as all but the very largest animals are usually vulnerable to some predator higher up on the food chain. In some of the examples illustrated, the animals were quite easy to see, as the composition, focus, and depth of field isolated the subject, removing the distractions and competing visual elements that would normally draw away the eye and would otherwise keep the animal unseen.

This section puts these camouflage modes into context, giving you a better appreciation perhaps for how effective various forms of concealment are, and how difficult it can be to see cryptic creatures in the wild. Nonetheless, you the reader are seeing only a tiny window into an animal's world via a macro or a telephoto lens where only six per cent or less of a 360° diorama is involved, and that's not considering the dome that may extend above you in a forest or a jungle, or the spherical world you may encounter snorkeling or scuba diving beneath the sea.

In the 'real' world an animal, be that an insect, a bird, a fish, or anything else, is more likely to not be the most obvious or conspicuous object you see. Quite the reverse, actually, as bright spots from stones or flowers, or reflected light from leaves or branches, draw the eye away instead. Patterns or shapes layered over one another produce visual confusion, enabling cryptic creatures to remain unnoticed. Inexperienced naturalists and nature enthusiasts are frequently victim to this, dismissing the tiny details that would reveal a hidden treasure. Those with experience, however, often develop an effective 'search image' that allows them to recognize the tiniest of details, and thus discern some animal that may have been hiding in plain sight.

The discoveries one makes when one finally sees a hidden creature are always refreshing and rewarding, far more so, I think, than the simple observations one may make when an animal is plainly in view and immediately recognized. There are no 'ah ha!' moments involved with those sightings. But there surely are when you finally see an animal that is right before you but where your eyes and mind had failed to connect the patterns or the shapes into a recognizable form. I'm sure if you've ever been on an African safari, or been guided to virtually any tropical destination, you have made a comment like 'how did you see that?' As you page through this section, you might remind yourself that even as you see these camouflaged subjects, you are only seeing a vignette of the whole, confusing and chaotic picture of the natural world.

Opposite: A tiny crab blends in perfectly with the background in its habitat of broken coral fragments.

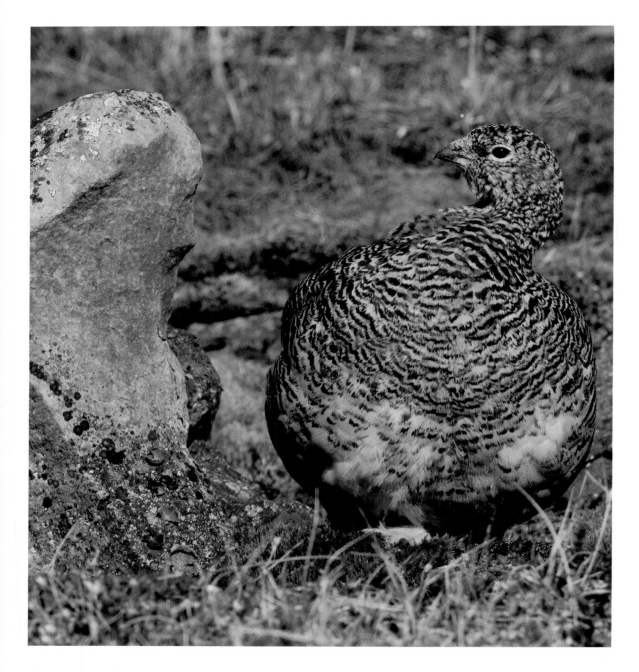

Above: The drab base coloration and the banded feathers conceal this Rock Ptarmigan even when in plain sight. In this case the eye draws your attention and a well-defined shadow outlines its form, making it fairly easy to spot the bird in this image. On the tundra, however, the coloration and pattern matched its background so well that we often lost track of the bird if we looked away for a few seconds.

Opposite: Resembling another broken limb on an ancient tree, a Collared Scops Owl sits motionless through the day, thus avoiding the unwelcome attention of songbirds. The songbirds ire is justified, for in addition to eating insects, small rodents and reptiles, owls will capture small birds if they have a chance.

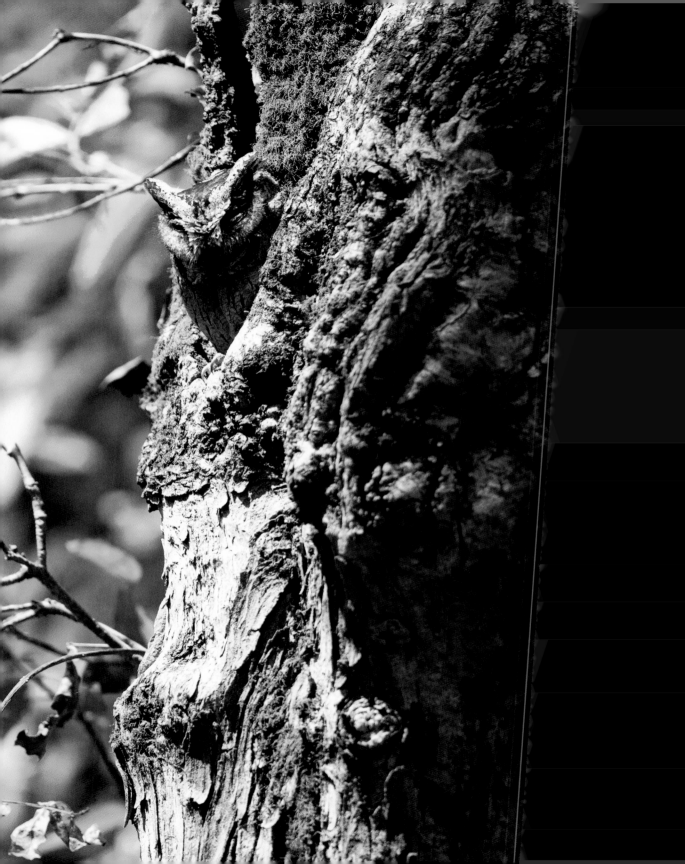

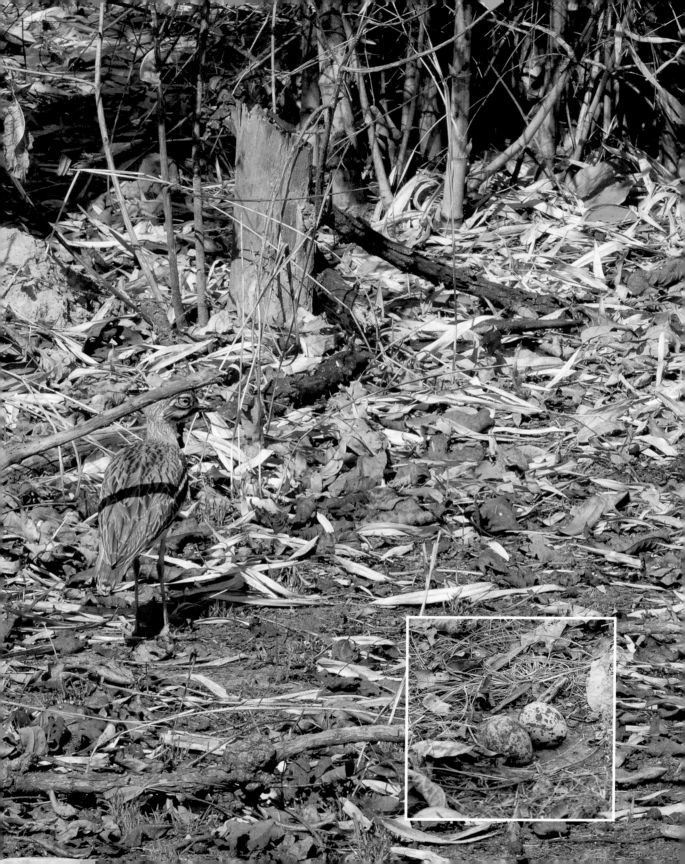

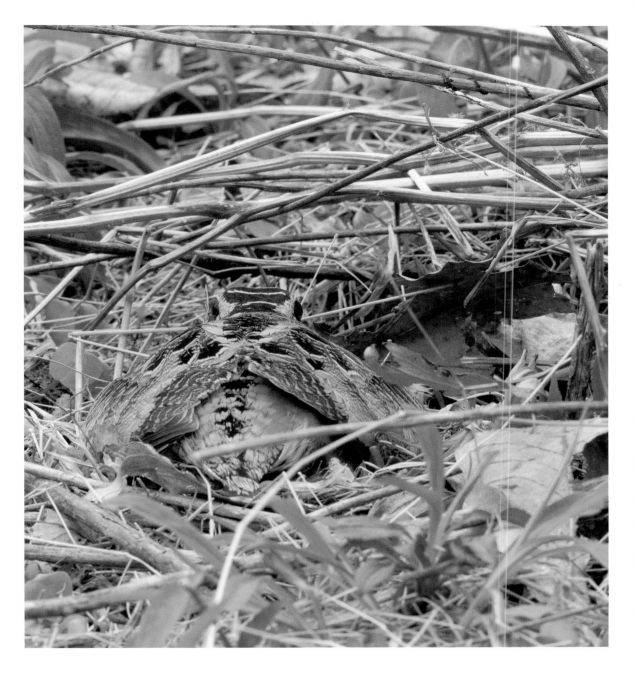

Above: The eyes of this American Woodcock bulge slightly from either side of the bird's head, giving it nearly a 360° view. Nesting birds are keenly aware of their surroundings and will only shift positions or roll their eggs when they are sure nothing is nearby to spot the movement.

Opposite: The thick-knees, such as the Eurasian Stone-curlew (*pictured*), are a family of nocturnal shorebirds found in many locations worldwide. During the day these birds rarely move, relying on their cryptic pattern and coloration to remain invisible. Like most shorebirds, thick-knees make a very simple nest on the ground and lay eggs that match the landscape perfectly.

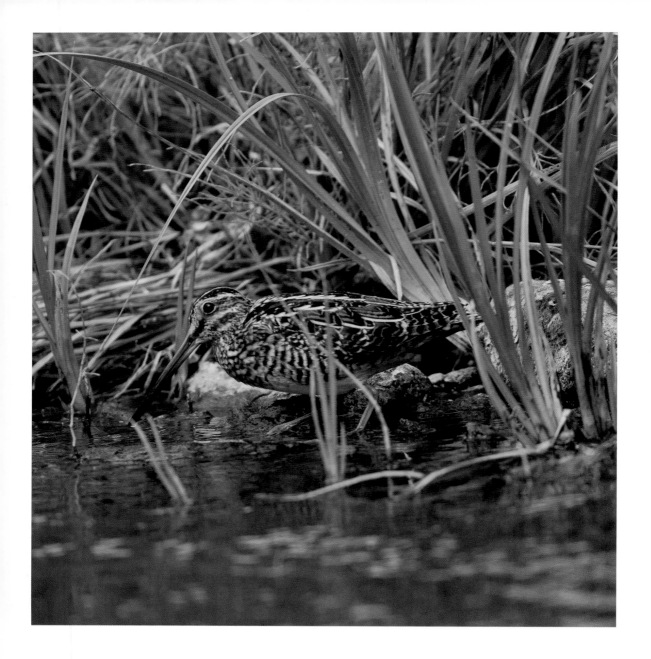

Above: Closely related to the woodcock, the Wilson's Snipe is also a true master of camouflage. Foraging for insects in marshes and along streams, its stripes and patterns blend in perfectly with leaves and grasses. Only if the bird moves is it visible, but even then one must still put together the cryptic pattern to see the bird.

Opposite: Perched on a ledge above a coastal waterway in western Alaska, the mottled plumage of this resting Rock Sandpiper blends in with the rocks, grasses and lichens. Vulnerable to avian predators like falcons, most species of sandpipers are well camouflaged to avoid detection when resting. Their disruptive coloration is particularly effective during nesting, as most shorebirds nest on the ground where they are vulnerable to both aerial and terrestrial predators.

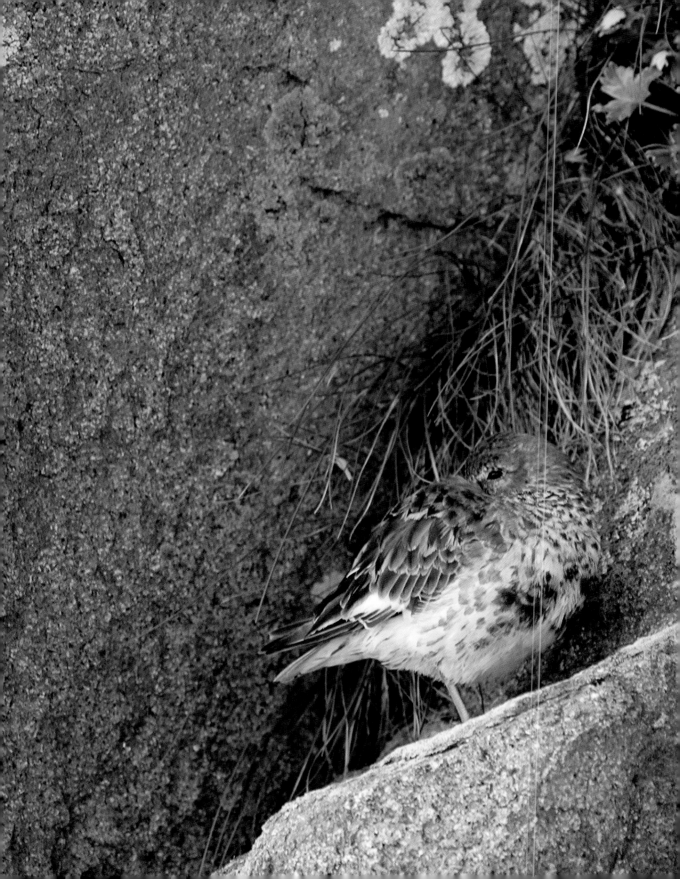

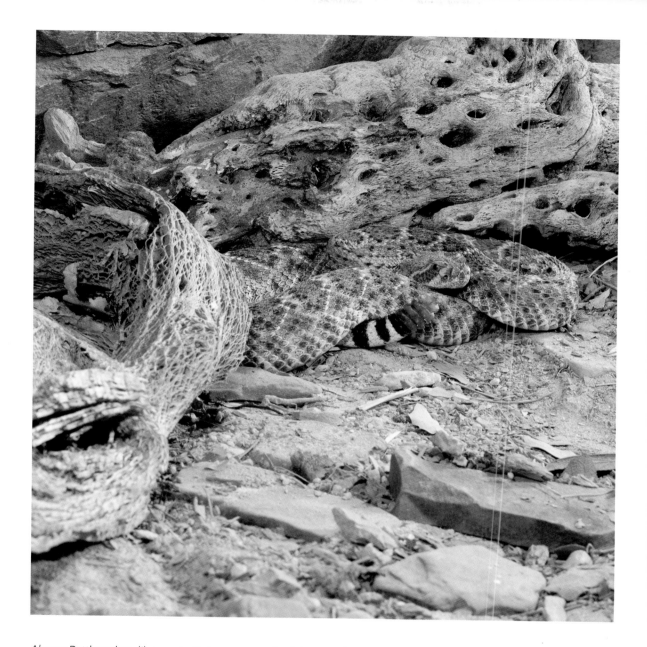

Above: Rattlesnakes, like most pit vipers, are ambush hunters, lying in wait beside a log or rock for a passing rodent. Lying motionless, and often half-hidden by their shelter, a pit viper poses a danger to an unwary hiker who steps over a log and places his foot directly on the snake. When hiking in snake country, it is wise to step onto and then beyond a log to avoid stepping on a hidden rattlesnake. Rattlesnakes are not aggressive but will bite out of reflex, or when they feel threatened or attacked. This is a Western Diamondback Rattlesnake.

Opposite: Rock agamas display sexual dimorphism, meaning that the sexes are differently coloured, patterned or shaped. Males are brilliantly coloured, with some species having orange or red heads, and others a cobalt blue. Female agamas are always inconspicuous and well camouflaged and are often seen only when the lizard moves. Hawks, small cats and snakes are their principal predators.

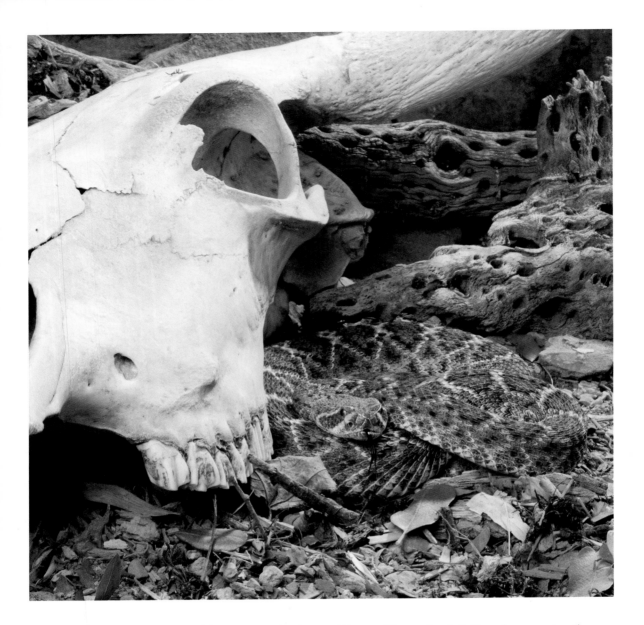

Above: Living in the hot deserts of the American South-west, Western Diamondback Rattlesnakes are primarily nocturnal. By day a rattlesnake may rest in the cool underground interior of a kangaroo rat's nest, emerging at dusk to lie in wait at an ambush site. Under the brightness of a full moon the light skull of this cow shines and draws the eye away from the well-camouflaged snake coiled beside it. While it is certainly possible and might be tempting to hike through the desert only by the light of a full moon, don't do it. In a night-time world of black and white a rattlesnake could be easily missed and a pleasant hike could suddenly become a crisis with one incautious step.

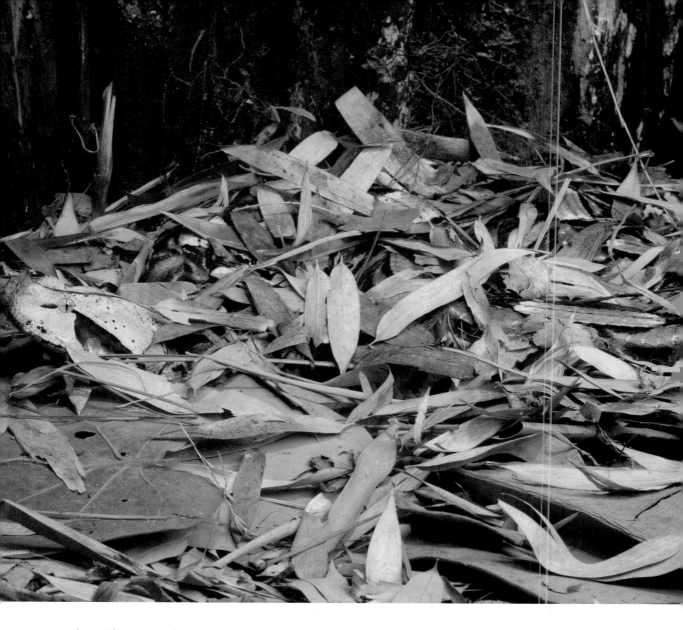

Above: The stout and extremely powerful Gaboon Viper lies in wait on the forest floor for its mammalian prey. While its colour pattern is striking and vivid when seen out of context, in the forests of central Africa the pattern merges to near invisibility against a background of fallen leaves. Gaboon Vipers often half-conceal themselves inside the leaf litter as well, making their camouflage even more effective.

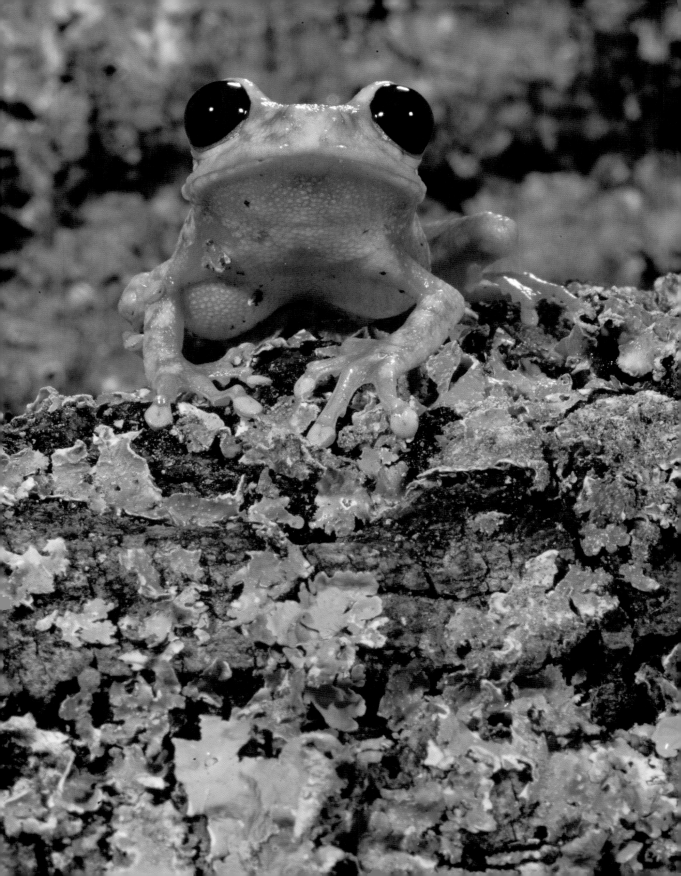

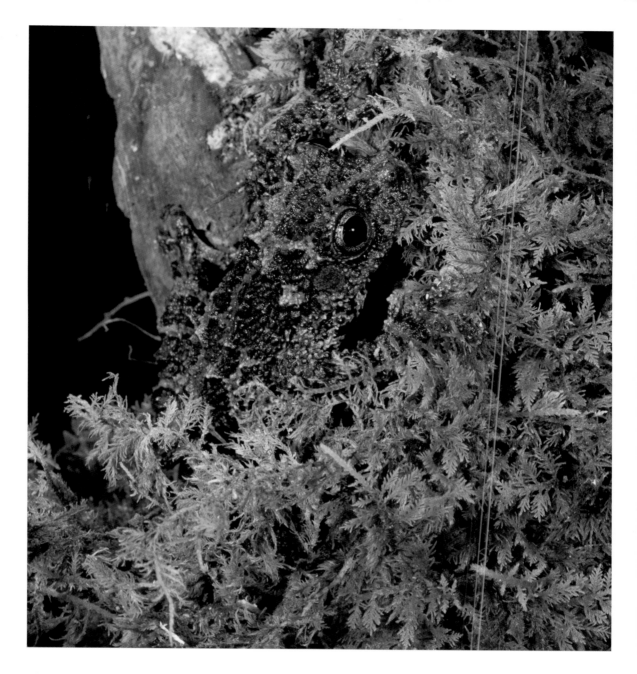

Above: One of the amphibian world's most cryptic frogs, the appropriately named Vietnamese Mossy Frog, blends in seamlessly with the mosses of its moist environment. Outside of the breeding season, when this phantom is silent, the frog is rarely seen. During the breeding season males gather at pools, calling to attract mates and sadly, also attracting collectors who gather them for the exotic animal pet trade.

Opposite: By day many treefrogs hunker down with their eyes closed and hidden, their bodies pressed against tree bark or nestled into a crack or hollow log. Under the cover of darkness the Big-eyed Treefrog emerges, its conspicuous black eyes now revealed and apparent, at least under the beam of a strong headlamp.

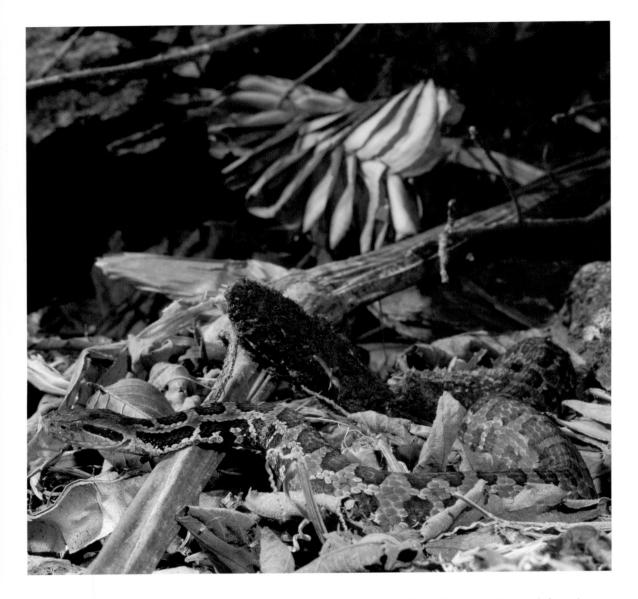

Above: In Costa Rican forests a Godman's Pit Viper lies unnoticed in the leaf litter. Related to the much-feared Fer-de-lance, these snakes may lie in ambush at the base of a tree or beside a log for weeks on end, unmoving and waiting. They may employ three senses as they hunt. Pit vipers have vertical pupils, which is typical of night hunters, as these pupils can widen at night and shrink to thin slits by day. They may also detect prey via their tongue, transmitting chemical messages to special receptors, called Jacobson's organs, located in the roof of their mouth. Pit vipers also rely heavily on thermal signatures, as the heat-sensitive pits between their eyes and nostrils detect warm-blooded prey even in complete darkness from a distance of about 10cm (4in).

Opposite: Swimming through the muck and leaf detritus of its aquatic habitat, the Stinkpot Turtle is easily missed unless one catches a movement or notices its facial stripes, which help to break up the outline of the head. These freshwater turtles of the north-eastern United States rarely leave the quiet waters of ponds and slow-moving streams except to lay eggs.

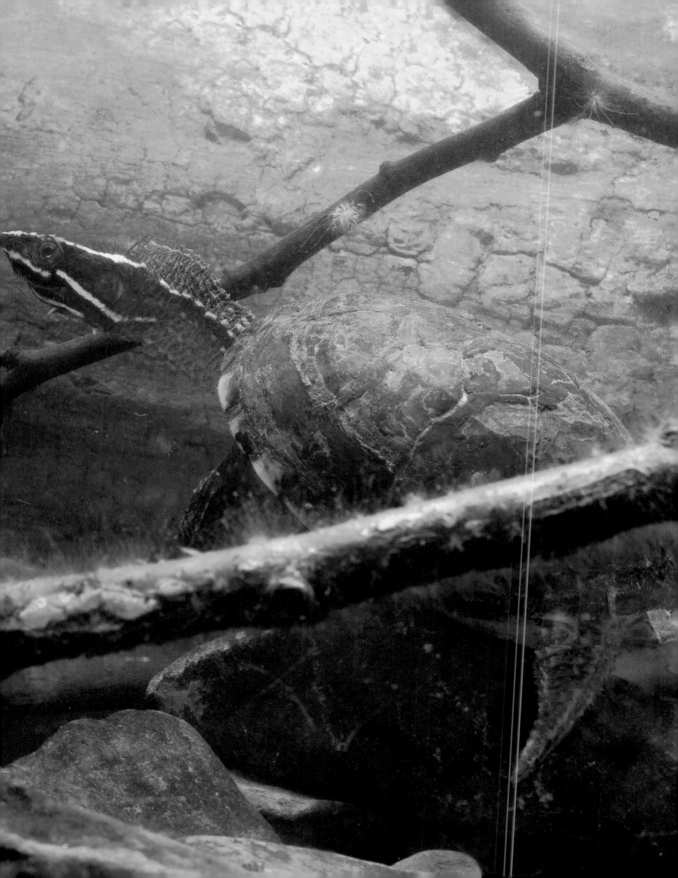

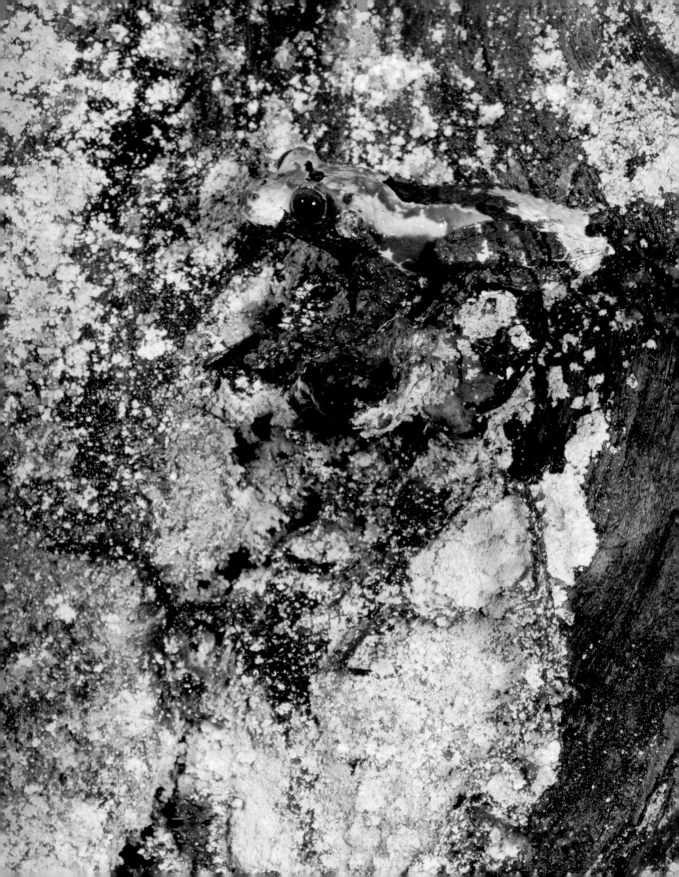

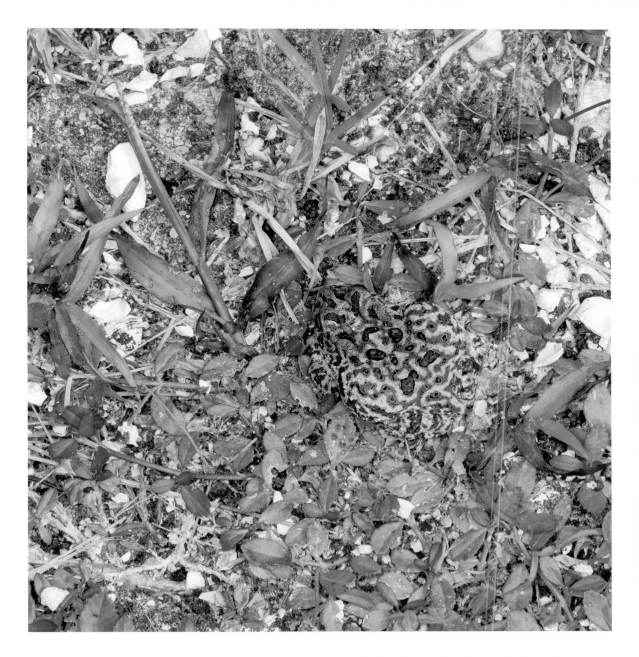

Above: The enlarged parotid glands, located behind the eyes, and other skin glands (the so-called warts) protect most toads from predation, making them unpalatable and inducing nausea or, in some species, death if consumed. Protected by this potent defence, toads are perhaps the most conspicuous members of the amphibian class, but most nonetheless utilize some form of camouflage as well. The mottled pattern of this Fowler's Toad blends in perfectly with the vegetative ground cover and stones in this central Florida forest clearing.

Opposite: Sitting motionless on a lichen-covered tree trunk the Brown Mossy Frog is nearly invisible. The patches of light and dark pigments characteristic of disruptive coloration effectively break up the outline of this small frog, and only its round, black eye betrays its presence.

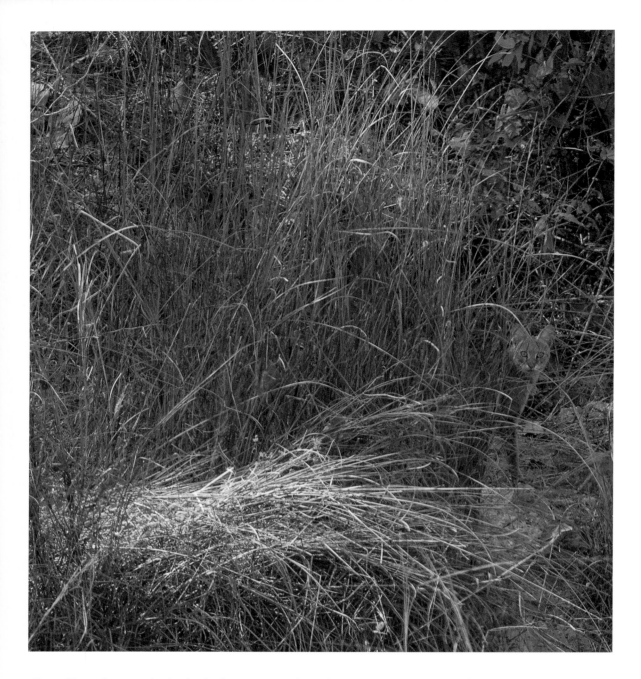

Above: Throughout much of India the house cat-sized Jungle Cat is the most common feline, although its shy nature and cryptic coloration makes it easy to miss. Jungle Cats occupy a wide range of habitats, from grassland to forest, where they hunt a variety of small animals, including frogs, lizards, rodents and ground-nesting birds.

Opposite: A Bengal Tiger in Bandhavgarh National Park in central India is barely discernible amidst the leaves and shadows of a bamboo thicket. Employing disruptive coloration and countershading a Tiger will seemingly vanish before your eyes just seconds after entering a forest. Like many of the big cats, Tigers are ambush hunters, stalking to within metres of their prey to make a short rush before executing a final, deadly leap.

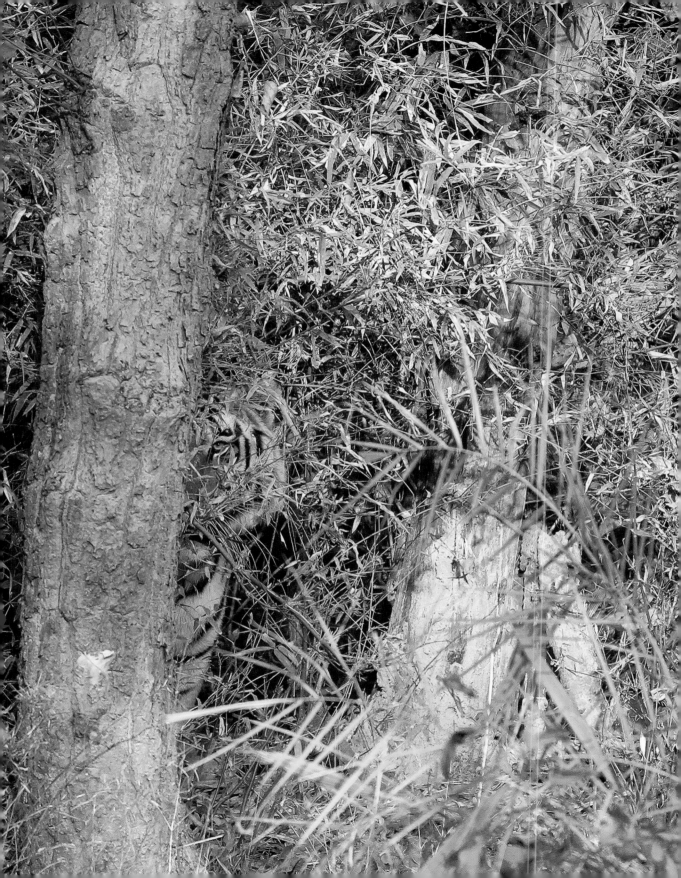

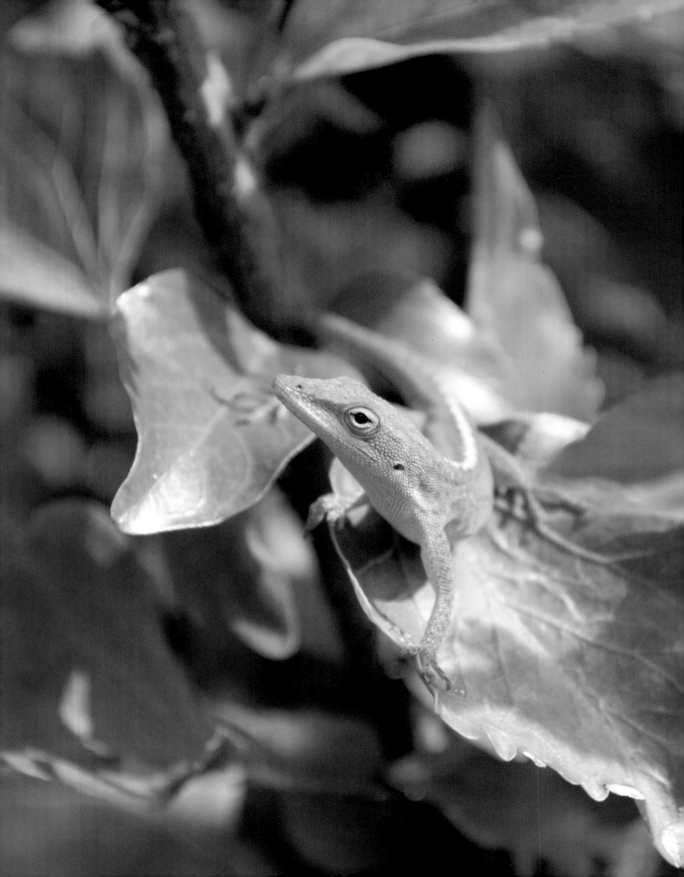

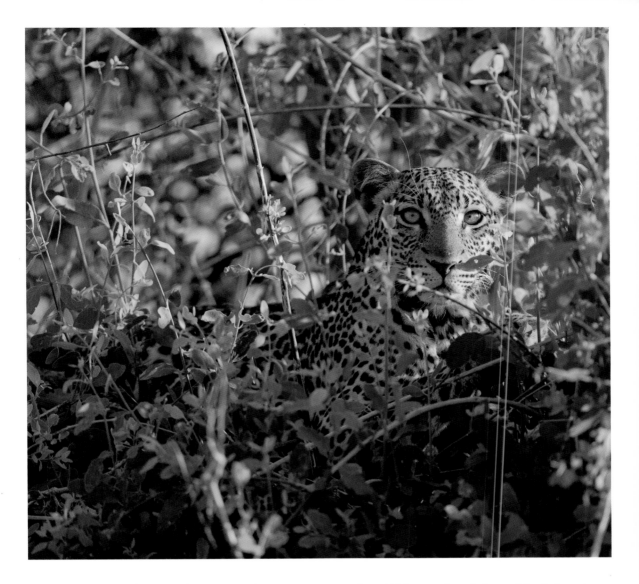

Above: Lying in a low tree an African Leopard surveys its surroundings. While once heavily hunted for their coats to supply a misguided fashion industry, today the Leopard is the most widespread of the world's big cats with a worldwide population that may number 200,000. Leopards are found in many parts of Africa, in scattered locations in the Middle East, and throughout southern and eastern Asia. While all have spots, their base colour can range from a nearly white coat to jet black.

Opposite: Carolina Anoles, also called Green Anoles, are sometimes mistaken for chameleons because of their ability to change colour. Sharing another unusual adaption with true chameleons, anoles can independently rotate their eyes as well, but there the similarity ends. Once collected by the hundreds of thousands for the pet trade, Carolina Anoles face an even more deadly threat today. Brown Anoles, introduced into south Florida, have spread throughout much of the species' range and replaced their green cousins. Brown Anoles not only compete for the same food and habitat, but adults are likely to prey upon juvenile Carolina Anoles as well. The result – it is rare to find a beautiful Carolina Anole in many parts of its former habitat.

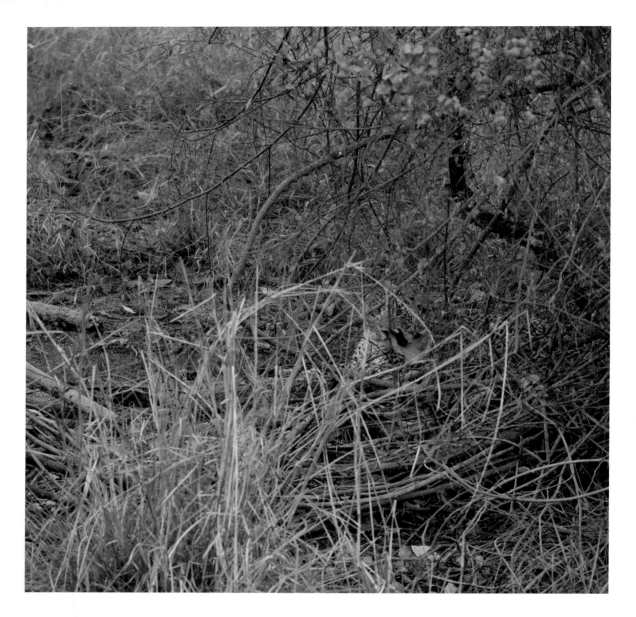

Above: Hiding in a tangle of branches, this Asiatic Leopard watches a distant herd of Spotted Deer. While the white chest of this Leopard may reveal its location to you, that tell-tale clue would be meaningless for the prey animals unless the cat moved, as motion draws attention. Should the Leopard flick its tail, as they are apt to do, this movement might be spotted by langur monkeys that often are found associated with deer. Langurs will sound an alarm, and soon the forest will ring with the barks of monkeys and the honking blows of Spotted Deer.

Opposite: Even though this Jaguar occupies the centre of the frame it may take a moment to actually see this big cat. The Jaguar's spotted pattern is a classic example of disruptive coloration, as the black spots and rosettes confuse the eye and break up the animal's outline. Like Leopards, Jaguars have two morphs – the typical spotted form and also a black morph. The latter is rare and most often seen in the Amazon Basin where, in climax forest, it blends in with the deep shadows on the forest floor.

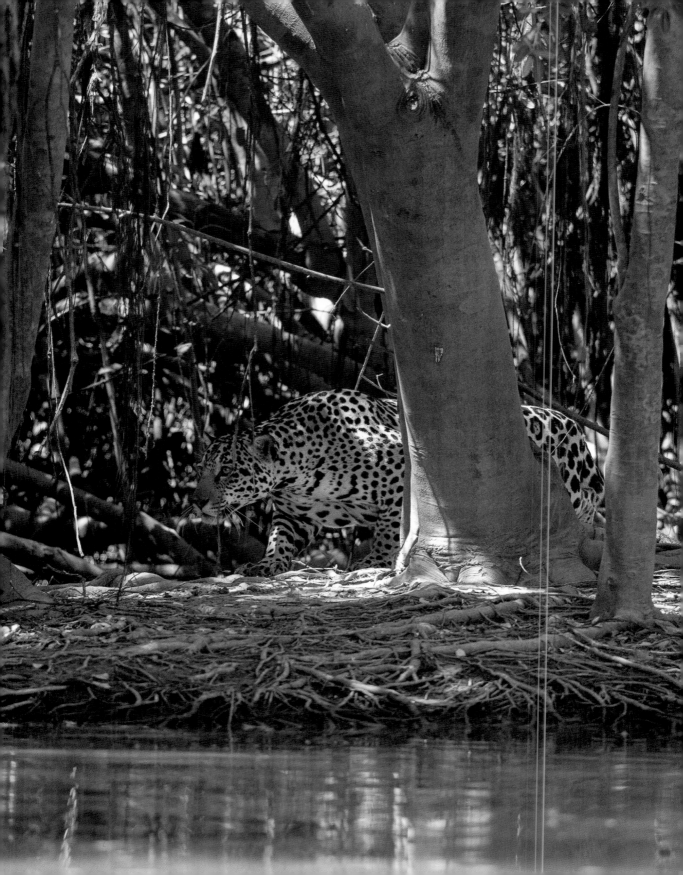

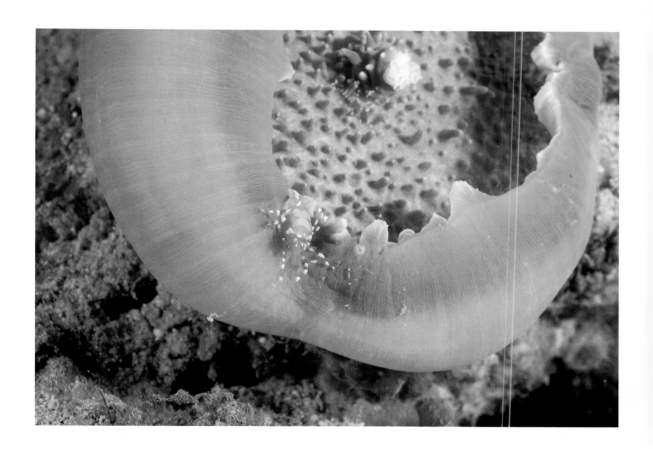

Opposite: Resembling a galaxy of stars, a slender decorator crab is barely discernible against its background. While many crabs are scavengers or filter feeders and do not require camouflage for procuring food, nearly all but the largest species face a myriad of predators, making camouflage essential for survival.

Above: Resting on the edge of a sea anemone this Hidden Corallimorph Shrimp is clearly visible. Inside the bowl of the anemone the shrimp's matching coloration and pattern would conceal it effectively.

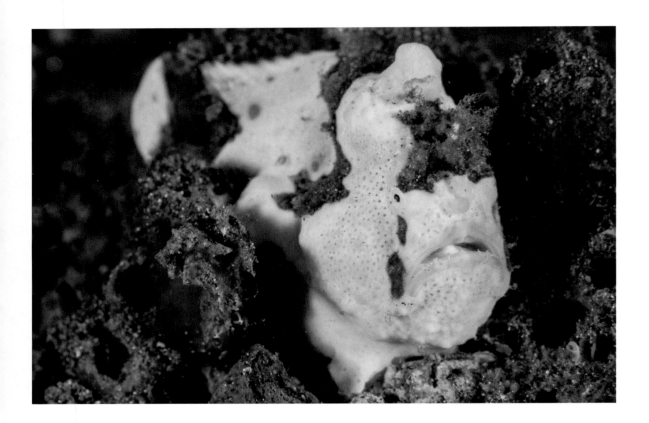

Opposite and above: Frogfish are experts at disguise. Resembling a rough block of whitened coral the frogfish in the image above lies in wait for a passing crustacean or small fish. The dark bands break up the otherwise white fish into several parts, disrupting the typical fish shape or outline.

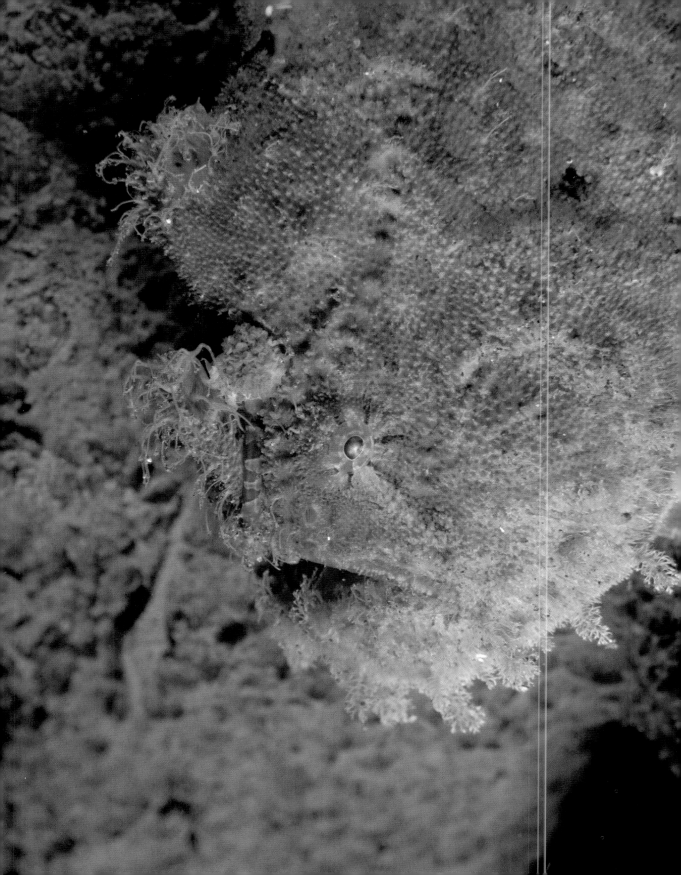

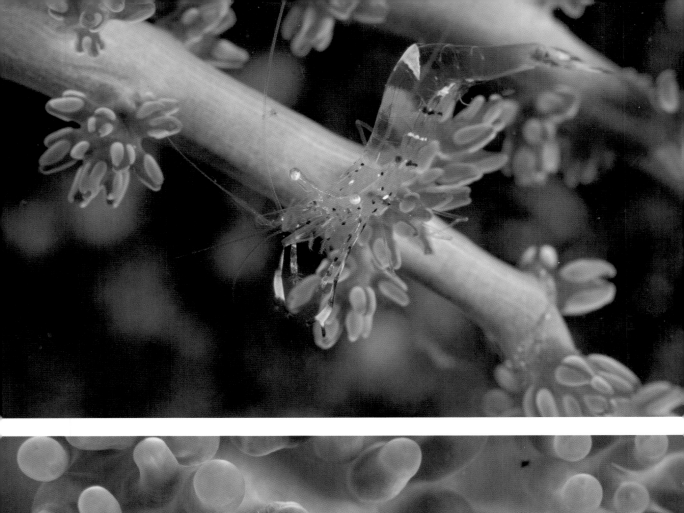

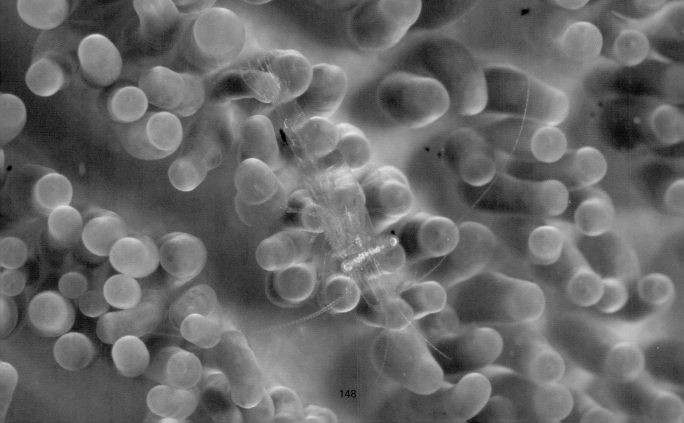

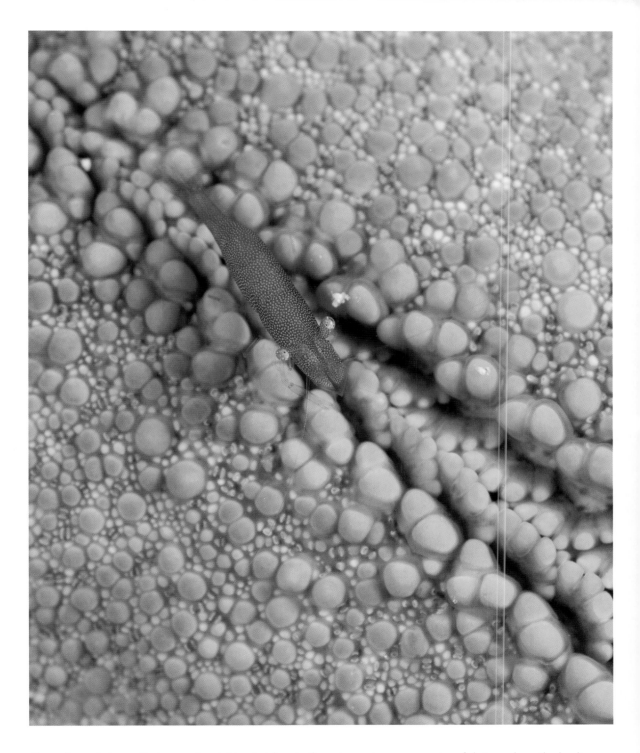

Opposite and above: Background matching is taken to the extreme in some species of shrimp where the bodies are translucent, revealing the colours and structures the shrimp rests upon, including the stinging tentacles of a sea anemone. In the case of the commensal shrimp it is protected two ways; by its own camouflage and translucency, and by its association with an organism equipped with stinging nematocysts that will deter potential predators.

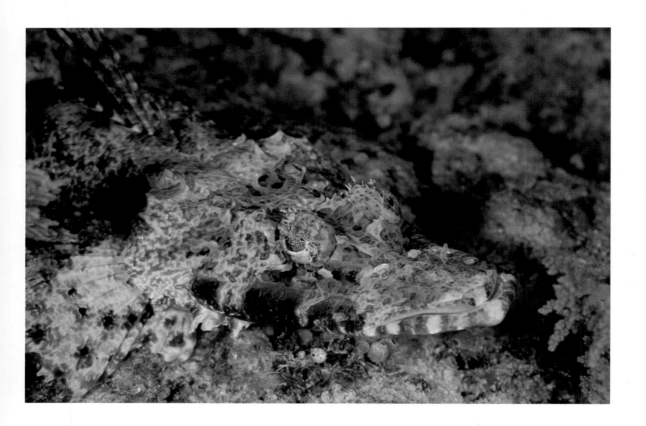

Above and opposite: The superb camouflage of this Indonesian Crocodilefish (*above*) is quite similar to that used by the leaf-tailed geckos (*opposite*), where fins or flanges of skin press against the substrate to eliminate shadows and the animal's outline. These disparate species are both ambush hunters and are potential prey items to larger predators, and their camouflage provides the necessary concealment for both contingencies.

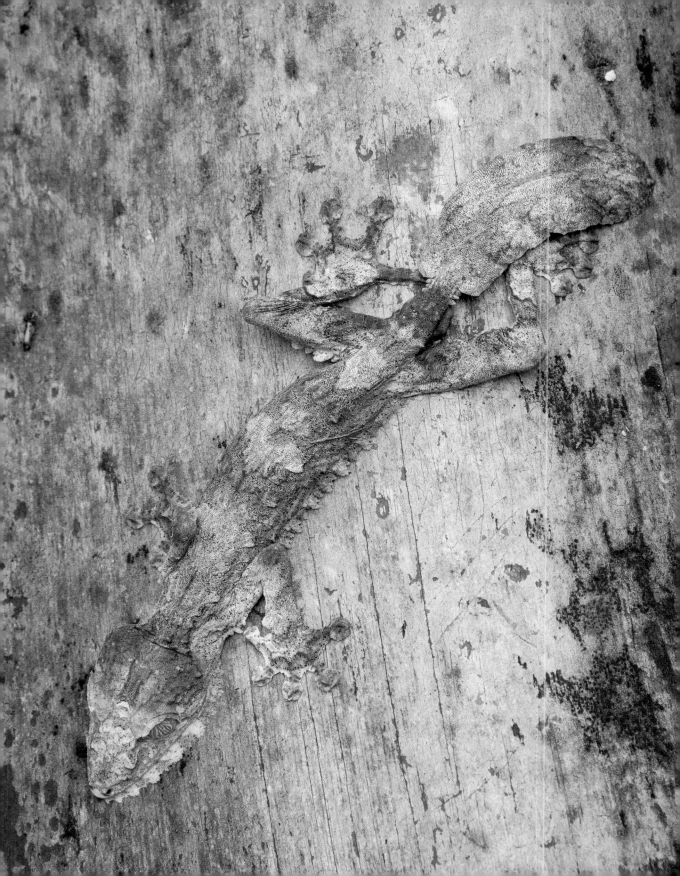

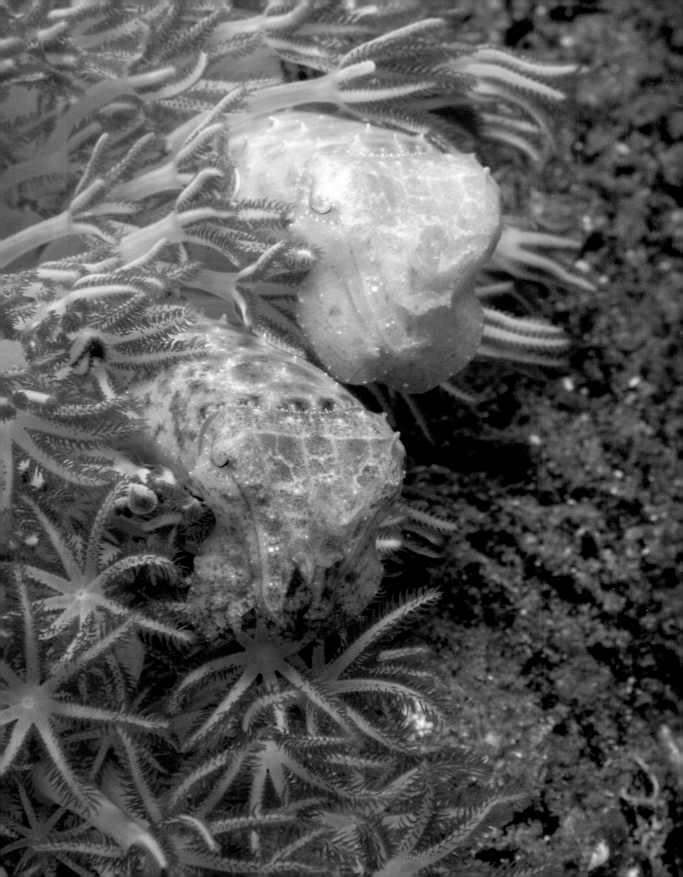

Above: Around the world a variety of moths – such as this Mottled Beauty from Europe – rest upon tree bark during the day, flattening their wings to eliminate shadows and using disruptive coloration to break up their outline, keeping them safe from insect-eating birds. At night, when moths are active, their visual camouflage is no longer effective against bats and nightjars, although some species of moths can detect the ultrasonic squeaks of hunting bats and then drop to the ground to escape predation.

Opposite: If it were not for the faintly visible eyes of this pair of crinoid cuttlefish, a diver would likely miss seeing these cryptic critters. By day the cuttlefish rests among the crinoid corals, leaving its shelter at night to seek prey.

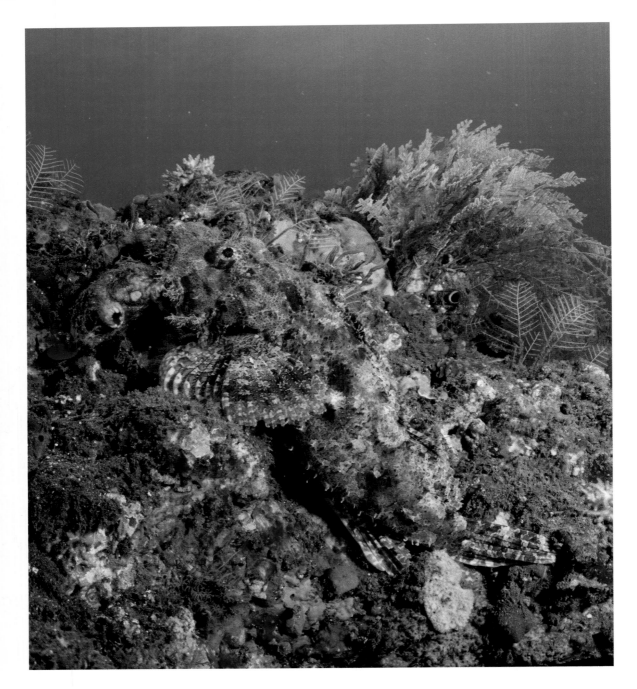

Above and opposite: It is easy to miss a scorpionfish as it rests in a rock or coral hollow, but it is even better not to step on one of these well-camouflaged fish. Scorpionfish possess several spines covered with a venomous mucous that can inflict a painful jab, at best, or a fatal wound if stepped upon by a diver or snorkeler. Most are superbly camouflaged, but the lionfishes are quite gaudy and conspicuous, and these species are popular saltwater aquarium pets. Unfortunately lionfish, native to the Pacific and Indian Oceans, have been introduced to the waters of the eastern United States and the Caribbean. With no natural predators, and a voracious appetite, lionfish are decimating native reef fish populations throughout their new range.

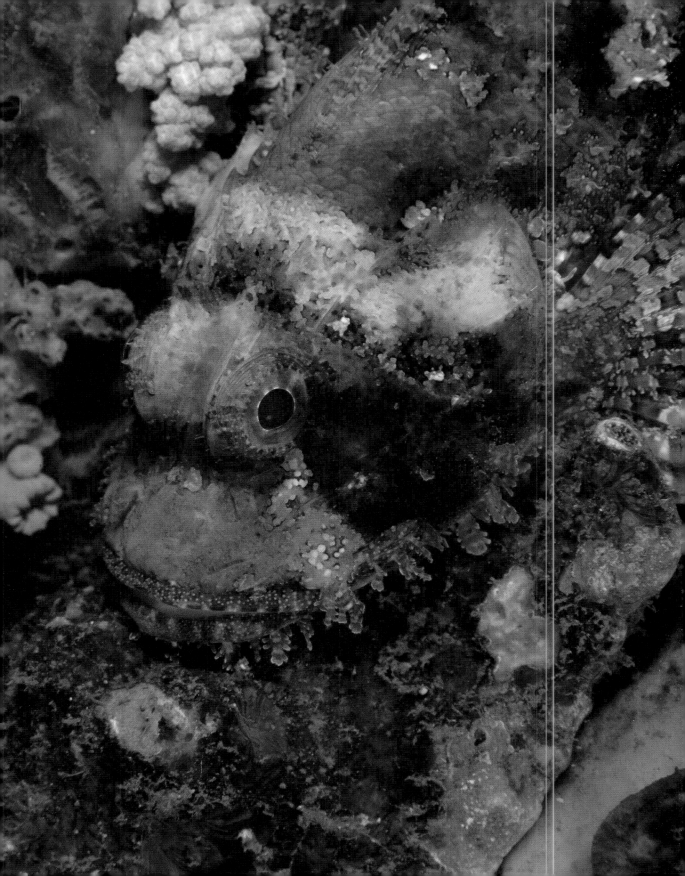

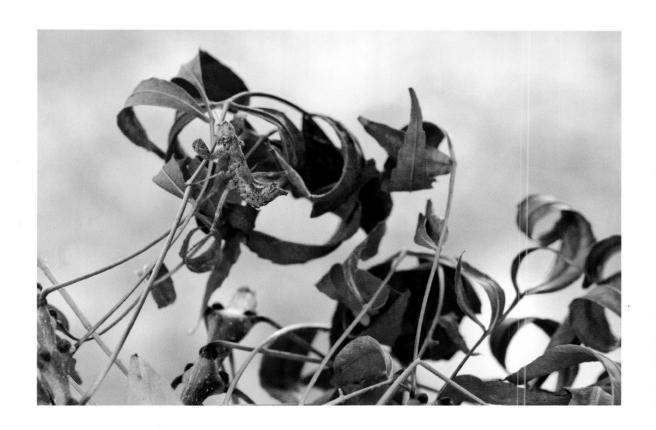

Above: Mantids around the world are masters of camouflage. All share the powerful forelegs which they hold in a praying pose, but other aspects of their body configuration vary widely. Some, like the flower mantids shown earlier, are so ornate that they could easily pass for a real flower, while others are carbon copies of dead leaves. Some, like the Carolina Mantis, are more traditionally proportioned with a typical insect's shape, but their plain green or brown background matching still provides the necessary camouflage.

Opposite: You must look carefully to discover this male dobsonfly at rest on a streamside tree. Male dobsonflies are characterized by fierce-looking mandibles but these large jaws are harmless. Ironically, it is the female dobsonfly, with insignificant-looking jaws, that can deliver a painful bite. Dobsonfly larvae, called hellgrammites, are aquatic and relatively large, and are very popular as fishing bait. The larvae are predacious and equipped with powerful, albeit short jaws, and they will bite when handled. Adult dobsonflies are among the largest insects outside of the butterfly and moth group.

ACKNOWLEDGEMENTS

Mary Ann and I lead photography tours and safaris, and a large number of the images in this book were made on our various trips in the company of our participants. Many of those people have travelled with us for years and have become our very good friends and I'd like to thank everyone who has accompanied us afield for their enthusiasm and energy. These enthusiastic photographers have made our photography and our trips an enjoyable endeavour. While too numerous to mention everyone here, I'd like to recognize a few good friends for all of their help in making our trips successful. Special thanks go to Bill Sailer, Tom Wester, Carolyn Hooper and Sam Maglione, who have shared a lot of our photo adventures both abroad and at our home at Hoot Hollow. Special thanks go to Greg Basco for his help in setting up our Costa Rica tours, and to Joe Van Os for our Antarctic Peninsula visits, and for having the distinction of being our number one business competitor while still being a good friend.

Clyde and Chad Peeling, father and son owners of Reptiland, an AAZP accredited zoo, and my friends Dave Northcott and Gary Lee have been extremely helpful in supplying many of the reptiles and amphibians photographed for this book. My good friends and fellow photographers, Don Lewis, Judy Johnson and Sue Altenburg, supplied images that I lacked, helping to make this a truly beautiful and visual book.

A lot of photographic equipment was involved in all this shooting, and I must thank Joe Johnson, Mark Gvazinskas and Jim Weise from the Really Right Stuff for their help with gear, and the late Allen Leichter and his son Brandon for their help with camera gear and lenses.

Last, of course, are my thanks and love to my wife, Mary Ann, who shares my passion, who travels and photographs with me, and who makes my life so much easier and joyful. I couldn't do it without her!

Joe McDonald

IMAGE CREDITS

All images by Joe McDonald and Mary Ann McDonald except for the following:

Sue Altenburg: page 139.

Dreamstime.com (individual photographer names in brackets): pages 12 (Judith Bicking); 17 (Feathercollector); 19 (Photographerlondon); 94 below right (Orlandin); 109 (Mopane); 140 (Wendy Roberts); 146 (Ethan Daniels); 153 (Whiskybottle); and 157 (Alessandro Canova).

Angus Fraser: page 71.

Judy Johnson: pages 9, 30, 31, 50, 80, 81, 94 top, 94 below left, 95, 96 above, 96 below, 97, 145, 147, 148 above, 148 below, 149, 150, 152 and 155.

Don Lewis: pages 33, 51, 144 and 154.

Shutterstock.com (individual photographer names in brackets): pages 1 (Anna Diederich); 2 (jo Crebbin); 4 (Bruce MacQueen); 6 (starfish flower); 14 (davemhuntphotography); 38 (studio on line); 64 (subin pumsom); 76 (Ryan M. Bolton); 79 (zhengzaishuru); 98 (lumen-digital); 101 (Dean Pennala); 120 (Justas Pilipavicius).

INDEX